LONDON
TAXIS
AT WAR

LONDON
TAXIS
AT WAR

ALF TOWNSEND

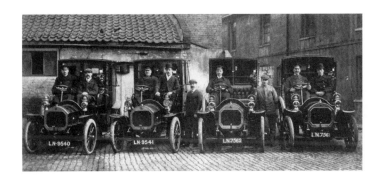

The
History
Press

Also by Alf Townsend

London Cabbie

Bad Lads: RAF National Service Remembered

Blitz Boy

The Black Cab Story

Heathrow Cabbie

Title page photograph: The Unic cabs. *(LVTA Archive)*

First published 2011

The History Press
The Mill, Brimscombe Port
Stroud, Gloucestershire, GL5 2QG
www.thehistorypress.co.uk

British Library Cataloguing in Publication Data.
A catalogue record for this book is available from the British Library.

ISBN 978 0 7524 5874 8

Typesetting and origination by The History Press
Printed in Great Britain

Contents

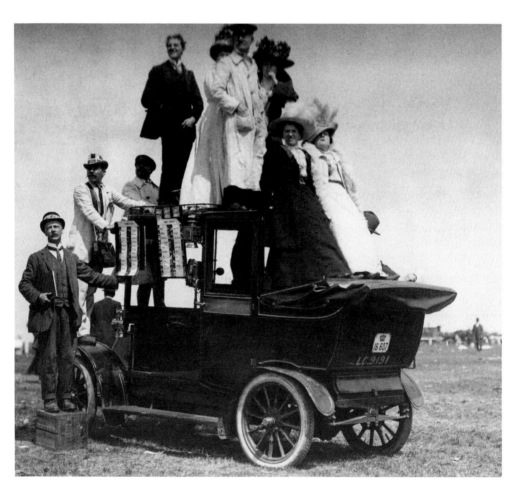

A day at Epsom races. *(LVTA Archive)*

Introduction

By the time this book is eventually published, I will have been driving my taxi around our great city of London for almost half a century – God willing! But I still retain a strong fascination about the longevity of our trade. What other group of cabbies anywhere in the world can boast of a history in excess of 350 years? When Oliver Cromwell first submitted his Ordinance to Parliament in 1654 for 'Ye Betterment of Hackney Carriage Drivers in London', he really became our founding father and many of the rules laid down all those years ago are still on the statute book today. Only the 6-mile legal requirement for a taxi journey has been changed by the former Mayor of London Ken Livingstone. He raised it to 12 miles and, in all honesty, that wasn't a bad move because the 6-mile limit was only put into place during the English Civil War in 1652, to protect the 'Hackneys' from going past the 6-mile fortifications and into danger.

Ever since I completed the dreaded Knowledge and first became a London cabbie in the early 1960s, I have always tried to put something back into the trade that I admire and respect. When the LTDA (the Licensed Taxi Drivers' Association) was first formed in 1967 as a breakaway group from the T&G, I was among the first to join and have been a member ever since. Almost from day one I became a regular contributor in the trade press to the LTDA's flagship magazine *Taxi* and have written a regular column of some 1,500 words every two weeks for over forty years. So the poor old London cabbie has been forced to look at my ugly mug staring out at them all that time!

Then I got involved in trade politics in the 1990s as senior LTDA Heathrow rep and helped to form the cabbie's co-operative HALT at Heathrow Airport. When I became chairman, I then started our own publication *The HALT Magazine* and ran it almost singlehandedly for nearly six years. When I finally resigned all my positions at Heathrow in 1999 following the tragic loss of our eldest daughter Jenny to breast cancer, the paper had expanded from an 8-page black and white effort into a 20-page, full colour front and back publication and, more to the point, it was entirely self-sufficient thanks to all the advertising revenue I had obtained.

The following year, in tandem with my trade journalism, I took on board what our lovely Jenny had always said to me. I took her advice and decided it was time to write a book about our famous trade and it was duly published as *Cabbie*. The hardback copy did so well that my publishers decided to do a paperback new edition. We redesigned the cover and renamed it *London Cabbie*, the title I originally wanted. Over the next four years I wrote a book every year – all moderately successful. Book number two was entitled *Bad Lads: RAF*

National Service Remembered and number three was *Blitz-Boy*, my story of growing up in the Second World War, the Blitz and of being evacuated. Then came *The Black Cab Story*, followed by *Heathrow Cabbie*, published in April 2010. So this effort, *London Taxis at War*, will become book number six – and still counting!

We start our story leading up to the outbreak of the First World War in London and the input of the cabbies to the war effort. Then we explore the plight of the cabbies attempting to work with run-down cabs, no fuel and not many drivers with all the young ones having enlisted. We then switch to the battlefields of the beleaguered French and British troops with their backs to Paris and the Germans just 25 kilometres away from their great city. So why am I including a French story some may ask, when the book is ostensibly about London cabbies? Firstly, because the two trades were closely connected and both the Paris and London cabbies were driving virtually the same taxi from 1907, the Renault two-seater with a two-cylinder gearbox, an 8.9hp engine and fitted with a three-speed gearbox. Secondly, the story is absolutely fascinating and almost hard to believe. Some historians have called the intervention of the 600 Paris taxis as 'The Miracle of The Marne' and, when you read the story, you may well agree.

We then move the story on after the Armistice in 1918 and the problems confronting all the young cabbies returning from the front. The old Unic cabs were falling to bits, yet other equally ancient taxis were still fetching sky-high prices on the market. The trade badly needed a new vehicle to keep the trade alive and it was the Beardmore Company in Paisley who solved the problem by producing an excellent series of new taxis up until the start of the Second World War.

We move forward some twenty-one years to the outbreak of the Second World War and spend the rest of the story understanding the bravery of the London cabbies as they carried on working through the Blitz, the Doodlebugs and the blackout – not forgetting the notorious 'pea-souper' fogs. Some cabbies joined the Auxiliary Fire Service (AFS) and drove their taxis – adapted as fire engines – right through the terrible bombings and massive fires that devastated our great city. Other cabbies drove their vehicles – now adapted as ambulances – through the rubble-strewn roads and saved many thousands of lives. They truly were some of the many unsung heroes of the Second World War.

But Hermann Goering, the head of the German Luftwaffe, had got it all wrong when he boasted to Hitler, 'Trust me, mein Führer, I will bomb the British into submission.'

I hope you enjoy the story – and all the wonderful photos as well.

Alf Townsend, 2011

Acknowledgements

This book entailed an awful lot of research, but my job was made easier by the kindness of one of my fellow London cabbies, Billy Eales – now retired.

For many years Bill, with the help of his trusty sound tape recorder, taped all the many stories told to him by the mature cabbies who had been driving throughout the Second World War. Bill, an excellent sketch artist, put all of these stories together – plus the stories of the London cabbies driving their taxis converted into fire appliances and produced a booklet called, *London Taxis at War 1939–1945*. Bill never had a literary agent and knew nothing of the publishing world, so his little gem was tucked away for many years. Then one day Bill got talking to one of his passengers who happened to be a very wealthy American guy and who was absolutely fascinated with anything to do with the war. Their friendship blossomed over many weeks, until eventually the American guy informed Bill that he had got a quote to have the book self-published and that he would foot the bill! So Bill got down to work and produced some excellent sketches to go with the story.

I love the London taxi trade, but what I like most of all about it is the camaraderie that exists between the drivers – well, the mature ones anyway! When I phoned Bill and asked his permission to adapt some of his stories for my book, he didn't bat an eyelid and simply said, 'Be my guest, Alf, and use what you want.' So, thanks a million Bill and I hope my plug for your booklet bears fruition because it is well worth a read.

My thanks also to Graham Waite the archivist of the London Vintage Taxi Association (LVTA), whose members across the world lovingly and painstakingly restore these old beauties back to their former glory. If you want a good day out, just check out when they have one of their shows. Graham supplied me with 95 per cent of all the illustrations I required. All Graham asked for was a donation to the LVTA. Again it's about cabbies' camaraderie – thanks a million Graham.

Last but not least, my thanks to Stuart Pessock my editor on *Taxi*, who let me have a rummage through his extensive photo collection. Stuart also allows me to plug my books in the magazine on a regular basis – with the nod of approval from the executive of the LTDA, The Licensed Taxi Drivers' Association. When I thanked Bob Oddy, the general secretary of the association, his reply was indicative to many others I had thanked. 'You've done plenty for the trade over half a century, Alf, and it's the least we can do!'

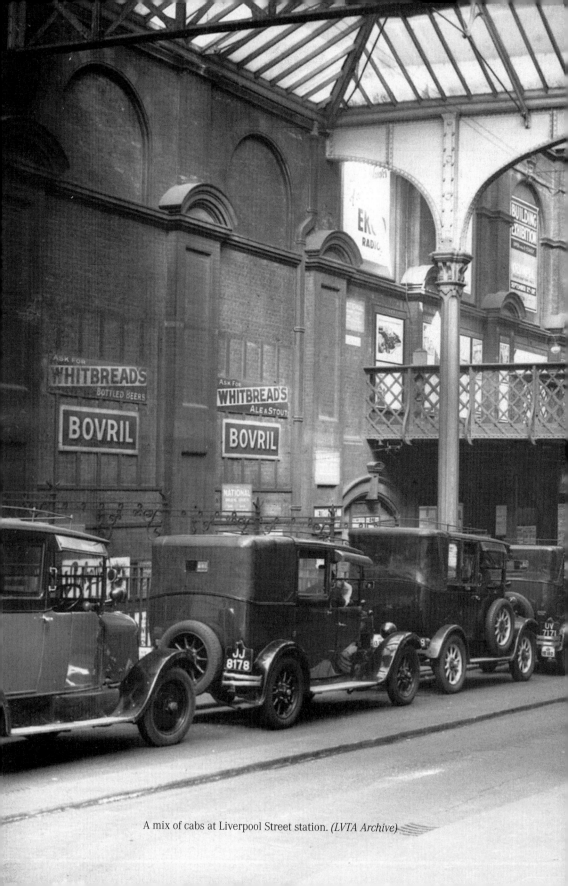

A mix of cabs at Liverpool Street station. *(LVTA Archive)*

CHAPTER ONE

London Taxis Before the First World War

The decade leading up to the First World War in 1914 proved to be a decisive one for the London taxi trade. The new century opened with over 11,000 horse-drawn cabs on the streets of London, 7,499 licensed Hansoms and 3,905 'Growlers' (the nickname for the four-seaters that carried all the luggage) and just one motor cab. Yet within the relative short space of ten years leading up to war, there were less than 2,000 remaining, but the number of motor cabs had increased to a massive 8,397! The Growler managed to survive a little longer because the railway companies wouldn't allow motor cabs on to their stations owing to insurance problems. This anomaly was finally resolved in 1910 and almost immediately the Growler was doomed overnight. Between 1910 and 1914 they had declined to just over 1,000. Despite the beautifully balanced Hansom cab being the most popular vehicle ever used by the cab trade, these wonderfully designed cabs were decreasing at a rate of 1,000 every year and now were being broken up for firewood and sold at a shilling a bag. Prime Minister Benjamin Disraeli once described them rather theatrically as, 'The Gondolas of London'.

In the old days, the Hansom cab could reach speeds of 17mph, yet today's average speed on the congested streets of London is just 11mph!

In 1897 the Bersey Electric vehicle hit the streets of the capital. This was the very first mechanical taxi in Britain and it was a veritable monster weighing some 14cwt – plus another 14cwt with its forty batteries of 80 volts each! It had a top speed of just 9mph and the massive batteries had a range of only 30 miles. The driver sat exposed at the front with a vertical steering column and twenty-two turns of the steering wheel was needed to move the front wheels from lock to lock! The cabbies quite liked them at first and because of the noise they made they were quickly known in cockney parlance as ''Umming Birds'. But the popularity of the Bersey was short-lived, because after six months of use they began to vibrate and rattle loudly because the huge battery boxes slid about and crashed against the floor of the cab. Another problem was the 30-mile range of their batteries preventing the drivers from accepting long fares – especially towards the end of their shift. As with many cabbies of today who refuse to go south of the river because, 'they get a nosebleed when passing water', it also provided the old cabbies with an excuse to turn down a fare if they thought they wouldn't find one to bring them back.

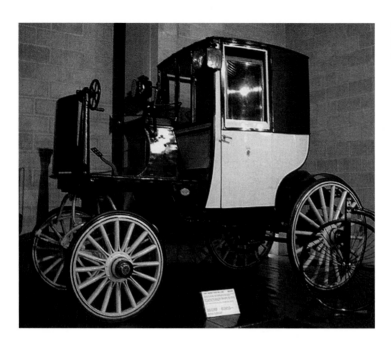

The massive Bersey Electric taxi – 'the 'Umming Bird'.

One of the stories goes that a punter hired an electric taxi in the West End and directed him to Hampstead, but when they reached Camden Town the cab suddenly stopped. 'I'm sorry guv,' said the cabbie, 'but the electric power has gone.' So the punter had to disembark, pay his fare and find another way to get home. Suddenly he looked round and saw the cab cruising comfortably back down Camden High Street, the 'miracle' of electric power having returned!

In 1898, the original twenty-five electric cabs were withdrawn from service and replaced by an updated version, but the new cabs were much nosier and they broke down so often that the cabbies didn't want to know. Coupled with this was the fact that the novelty of electric cabs was wearing a bit thin; punters were hiring less and the cost of batteries and tyre replacement proved much greater than the bosses had anticipated. So by 1899 the company was forced into liquidation and the electric taxi was no more.

The start of the new century heralded the arrival of the motor cabs onto the streets of London. This was the brainchild of Mr Davison Dalziel, later Lord Dalziel of Wooler. This gentleman had his finger in the pie of many original ideas, including introducing the Pullman cars on the rail networks. During my research I discovered that he died in 1928 and was buried in the Eastern Cemetery at Highgate. Imagine my surprise – and sadness – when I saw his giant mausoleum towering over the final resting place of our lovely eldest daughter Jenny who we tragically lost at Christmas 1999.

In December 1903, the very first petrol cab arrived in the shape of the French-built Prunel, followed by the Rational and the Vauxhall – with the driver perched high up behind the passengers like the traditional Hansom driver. A variety of makes followed over the next few years, including the Ford Model B and further French-built taxis like the Herald and the Sorex.

The Humber taxi.
(LVTA Archive)

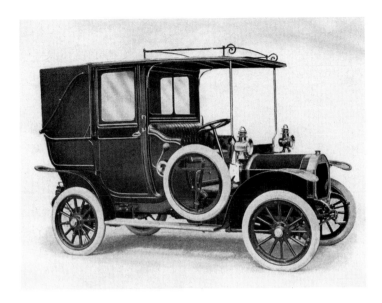

Charlie Brookes, a cabbie
from Fulham, in his Unic.
He had a small fleet
of cabs in the early to
mid-twentieth century.
(Chris Stuart)

The old two-seater Unics. *(LVTA Archive)*

She's seen better days, this Unic! *(LVTA Archive)*

The faithful old Unic.
(LVTA Archive)

The Renault taxi.
(LVTA Archive)

The influx of French-built taxis included the Unic (used in large numbers up to the 1930s), Darracqs and Belsize, and these were used alongside the British-built Wolseley-Siddeley and the Italian Fiats.

The arrival of 500 Renault taxis ordered by the massive General Motor Cab Co. of Brixton really did cause a sensation. The company was accused of 'going foreign' and failing to support the British-made taxis. These Renault two-seaters were virtually the same as those working in Paris and fitted with a two-cylinder, 8.9hp engine and three-speed gearbox. They proved so popular that by the end of the year a further 600 went into service. But the French-made vehicles didn't have it all their own way and between 1903 and 1914 some 38 different motor manufacturers had vehicles working as taxis in London. This became a big problem for the poor old cabbie when the authorities

The 1911 Renault. *(LVTA Archive)*

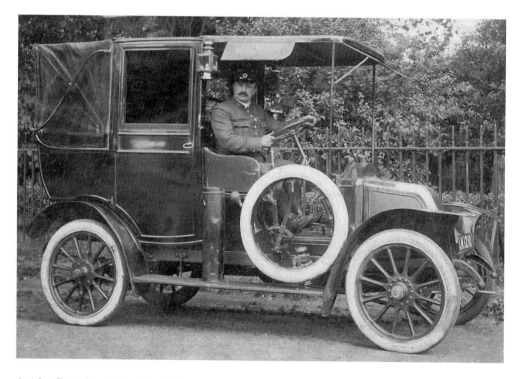

Another Renault taxi. *(LVTA Archive)*

insisted that they be tested on every type of cab they drove. Many drivers failed their test for second and third types of cabs, as the gears, clutch, brake pedal and accelerators varied from model to model.

The most successful British cab of the period was probably the Napier, built at the Napier works in Acton. Their fleet was renowned for its smart livery and uniformed drivers and they even exported in large numbers to parts of the Commonwealth. It's hard to believe, but as late as 1910 the Commissioner of Police expressively forbade any glass screen in front of the driver to protect him from the elements – 'in the public interest'. It took another twenty-four years before a full screen was allowed – provided there was a device fitted to wipe the screen when it rained!

But the trade was in deep trouble because, even though their costs were ever increasing annually, the Home Secretary – one Winston Churchill – steadfastly refused the trade a fare increase. In fact taxi fares in London remained static from 1907 until two years after the Armistice in 1920.

Coupled with this crippling financial scenario, the cabbies' union called a massive strike in 1912 because the big fleet owners threatened to take away their extras – for luggage, extra passengers, etc. These extras were an integral part of the cabbies' earnings and later in that year, a Court of Arbitration finally found in favour of the union.

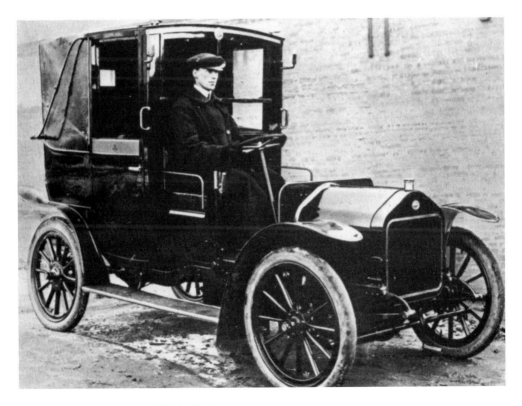

The Wolseley-Siddeley taxi. *(LVTA Archive)*

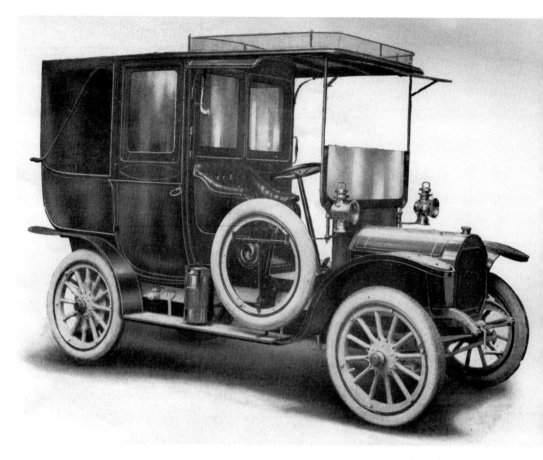

The Napier taxi. *(LVTA Archive)*

Yet another bitter strike ensued in 1913 over the 70 per cent increase on petrol prices and the fleet owners wanting to pass the whole increase on to the cabbies. This spluttered to a conclusion when some of the big fleet owners – desperate to have some money coming in before they went to the wall – did private deals with the union.

In between times these big fleet owners were being hit by even more stringent rules imposed on them by the governing body at the time, the Hackney Coach Office, when they decreed that all London taxis must be four-seaters. Those who had invested heavily in the two-seater Renaults – especially 'The London General' who had purchased 500 in 1907 and another 600 the following year – were faced with enormous conversion costs. The story of 'The London General' makes for interesting reading. They wouldn't let their fleet of 500 new Renaults out on the road until a workable meter was designed, accusing the cabbies of fiddling! Meanwhile, they had been secretly recruiting drivers who were willing to take out the cabs fitted with the 'Jewish pianos', or 'Zeigers', as the meters were nicknamed. Strange to relate that ever since 1823 when a Mr David Davies designed the very popular Cabriolet, we had been called 'Cabs' for short. Then in 1907, when a certain

The Humber taxi. *(LVTA Archive)*

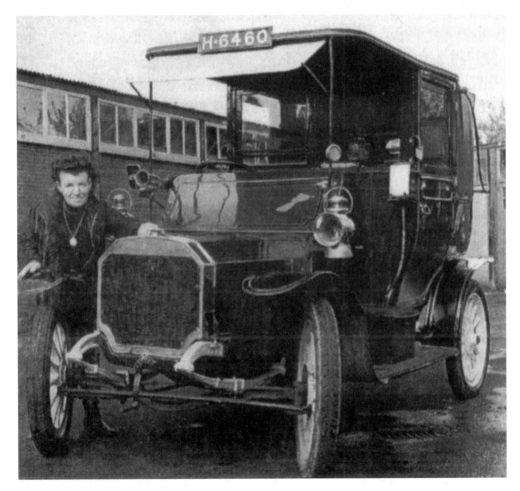

A 1910 Panhard taxi. *(LVTA Archive)*

German nobleman won first prize in the competition for his design of a workable meter, we have been called 'Taxis' ever since. The reason being that this German nobleman went by the grand title of Baron von Thurn und Taxis and he called his winning design a 'Taximeter'.

It's rather weird talking about the furore in the cab trade caused by Renaults in 1907, then witnessing a similar scenario some half a century later. This time it was some 200 red Renault Dauphines in the 1960s – all festooned in Air France livery ordered by Welbeck Motors, London's very first unlicensed minicab company, and it threatened the very fabric of the cab trade's longevity. We lobbied our brothers in the Dockers' Union pleading with them not to unload the cars at the Royal Docks, but to no avail.

The Renault Dauphines weren't the real problem, it was the mere fact that our government were allowing these people, who were using the Private Hire Laws, to blatantly bypass the stringent Hackney Carriage Laws that all we cabbies were forced to abide by. Welbeck Motors soon went bust, but their concept was modified by hundreds of backstreet entrepreneurs who made plenty of dough by renting out two-way radios to questionable drivers in 'rust buckets'. After some sixty years around 53,000 minicab drivers have now been licensed and now go by the very posh name of 'Private Hire'. These PH drivers don't have to endure the rigours of doing the Knowledge, simply apply for a PH licence and you're up and running. Even though they can only accept advance bookings and are not permitted to ply for hire, when the work is a bit thin on the ground, many of them resort to touting for fares at night. We, the professional cabbies, resent the fact that these PH drivers are given equal billing by Transport for London.

It was patently obvious to most people that all these different companies, who had jumped onto the bandwagon following the 'London General' explosion in 1907, wouldn't be able to stand the test of time because of the stagnant market – no fare increase, consequently nobody buying new cabs! Many of these owners were just entrepreneurs looking for a quick buck and they simply didn't understand the taxi game. By 1910 several large and well-known cab companies had been wound up, including the Reliance Cab Co., Express Motor Cab Co. and the Consolidated Cab Co.

And so the obvious was proved and, by the outbreak of the First World War, most of these companies who had entered the market in the boom years had already gone out of business, many of them transferring to manufacturing for the war effort. In fact, when the war started the only vehicles working on the streets of London as taxis were the ancient and worn-out Unics.

London Taxis in the First World War

The early days of the First World War, according to the writers of the time, generated an almost 'holiday atmosphere' in London. The city was packed full of people arriving by ferry and train from all the European countries under threat from the Germans – mostly American citizens who had left everything behind in a mad scramble to escape. For the first and only time during the four long years of the war, the London cabbies in their old Unics were doing a roaring trade.

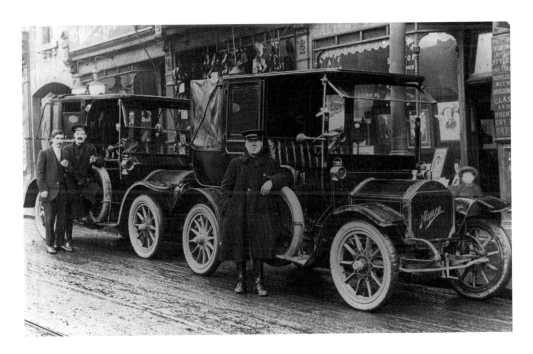

The Napier taxi. *(LVTA Archive)*

But it couldn't last and the London taxi trade – as with many other professions – was literally on its knees during the First World War. The vast majority of the younger drivers had answered the call 'For King and Country', leaving just the old boys to mooch about desperately searching for elusive fares, sometimes waiting on station ranks for over an hour. Petrol was on ration and the ancient Unics were slowly falling to bits and, even though women had been drafted in to cover the work of many of the men, driving a London taxi wasn't a viable alternative. The 'Knowledge of London', was introduced by Sir Richard Mayne, the then Commissioner of Police, in 1851 – allegedly in response from complaints by visitors to the Great Exhibition in 1850 that cabbies didn't know their way around the city. The dreaded Knowledge has to be completed by every wannabe cabbie and it would have been far too time-consuming for women to learn – in fact hostilities may well have finished while they were still studying!

At the risk of boring my regular readers – and my fellow cabbies – I need to explain to my new readers the full terrors of the Knowledge. After signing on at the Public Carriage Office (our controlling body) the wannabe cabbies are checked out to see if they've got a criminal record. After being accepted the guys and, following the Sex Discrimination Act of the early 1970s, the gals, are given a small white pamphlet showing some 400 routes – or runs – that criss-cross London within a 6-mile radius of Charing Cross station. Just why this pamphlet is known by all and sundry as 'The Blue Book', God only knows! Now the wannabe cabbies are on their own – they need to learn 'The Blue Book' inside out and backwards before they are ready to face an examiner for their monthly oral tests. But learning 'The Blue Book' inside out is not the end of their problems, they are expected to learn every one of the 25,000 streets inside that 6-mile radius – plus many thousands of 'points', such as hospitals, clubs, theatres, hotels, restaurants, railway stations and just about any destination the punter may request – even 'knocking shops'! This is not just about map-reading, it entails getting out on your scooter and seeing these 'points' and God help you if the merciless examiner thinks you've been sitting on your behind at home just reading a map instead of braving the elements. Back in my days of doing the Knowledge, one of the 'wise guys' was calling a run for the examiner and proceeded to turn right off of Holborn Viaduct into Farringdon Street – a drop of around 50ft. He was promptly slung off the course and told never to return.

Over a period of time your brain starts to store all this vast amount of information – a bit like a computer – and you start answering the questions. The length of your 'appearances' start to get shorter and before long you are ready for the suburbs and the stringent driving test. Then comes the day after three or four long years when the examiner says, 'Okay lad, I think that will do. Go and have a cup of tea while I fill in a few forms and get your Green Badge.' Oh, heady days and still remembered with great satisfaction after almost fifty years. I've always had a fascination about the way the iconic London taxi has evolved over some 350 years and the long history of the London cabbie. As a long-serving cabbie myself, I feel my credentials are worthy of telling this story.

But back to the First World War, our story now moves to the battlefields of France and the swift retreat by General Joffre, head of the French Army, and General John French, in charge of the British Expeditionary Force. They had retreated to the far side of the River Marne – just 25 kilometres from Paris – and their northern flank, consisting of the French

Paris taxis heading for the front in 1914. (*Pathé News Archive*)

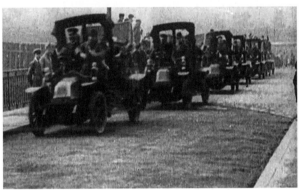

6th Army was ready to crumble. My readers may be asking – with some justification – why on earth is he prattling on about battles in France when the book is ostensibly about London taxis? Well firstly because it is a fascinating story and secondly, the operation was actually closely linked to the London taxi trade because we both drove the same vehicles as taxis, the Renault two-seaters.

On 1 August 1914 the Germans executed their Schlieffen Plan, which meant bypassing the strong French defences on the Franco-German border and attacking through neutral Belgium. Within a month they had raced up to the River Marne and Paris was within their grasp. But General Gallieni, in charge of the Paris Army, realised the danger and swiftly ordered the police to commandeer 600 Paris taxis – exactly the same Renault two-seaters as previously used in London prior to the 'four-door' edict that took them off the streets. The taxis, making two return trips and well overloaded, transported some 6,000 extra troops to bolster the northern flank. His quick thinking saved the day because the sudden influx of 6,000 fresh troops was enough to force the Germans back and they started to dig in, which was the beginning of four long years of trench warfare. This operation was cited later by historians as, 'The Miracle of The Marne'.

But the French still hadn't learned their lesson and between the wars their thinking in government was that any further conflict with Germany would again be a static battle. So they built the massive Maginot Line on their border with Germany – named after their Minister of War, André Maginot. But strangely this massive line of defences ended at the Ardennes Forest because they always believed it was impenetrable. Not so – the Germans, who bypassed the French defences in 1914, again executed the Schlieffen Plan, passing through the 'impenetrable' Ardennes Forest and attacking France from the rear. France surrendered in just three weeks.

The war was taking the lives of thousands of the young men who had stepped forward in their millions to fight after seeing Lord Kitchener's stirring poster exclaiming, 'Your Country Needs You'. This stirring patriotism was taken up by middle-class ladies at home in the UK who made themselves self-appointed 'guardians of Britain' – especially after the hugely publicised court cases concerning Conscientious Objectors. These ladies would roam the streets of London and, if they came upon a young man of serviceable age not in uniform, they would hand him a white feather, denoting cowardice. The unruly mobs were even worse, often chasing after them and shouting out, 'Bloody Conchie!', the derogatory name for the detested Conscientious Objectors. Nobody seemed to bother to ask the poor men if they had medical problems and been turned down by the forces. Not a bit of it, the truth being that these stupid people were jumpy and nervous and were only looking for scapegoats.

But it became all-too obvious that the favourite saying of the day, 'It will all be over by Christmas', was just a pipe dream! In London, the ancient taxi drivers in their equally ancient Unics were still striving to make a living. Working the day shift was reasonably safe and a relaxing visit to one of the famous taxi shelters for a quick cuppa and a natter to their mates broke the boredom of scouring the deserted streets for an elusive fare. These taxi shelters were purported to be the brainchild of a certain Captain Armstrong, the editor of the *Globe* newspaper, who lived in the swanky St John's Wood. In January 1875, as the story goes, he sent his servant out into a raging blizzard to engage a cab to take him to his office in Fleet Street. The poor guy came back a full hour later with a cab, absolutely soaked to the skin and, the good captain, now a bit miffed after waiting all that time, enquired why he had taken so long. He was told that although there were cabs on the rank, all the drivers had retired to a nearby grog shop to escape from the blizzard. As a God-fearing Victorian gentleman, the good captain was appalled that the cabmen had nowhere to shelter from the elements, so he spoke with many of his rich and influential friends on the matter. They all sympathised with the cabmen's plight, and decided to donate money for the erection of a shelter adjacent to the cab rank in Acacia Road, St John's Wood – very convenient for Captain Armstrong!

And so was born the London Cabmen's Shelter Fund. Between 1875 and 1950, forty-seven shelters were erected in London – all funded by the wealthy, God-fearing Victorians – but sadly over the next 135 years or so, due to new one-way systems and road changes, many of them were pulled down and their numbers today have declined to just thirteen. Over the years these taxi shelters have proved to be a fascination for the celebrities of the day – even though strictly speaking, only cabbies were allowed in.

But these remaining thirteen shelters are bastions to the longevity of the London taxi trade with great old nicknames like 'The All Nations' – named after the Great Exhibition

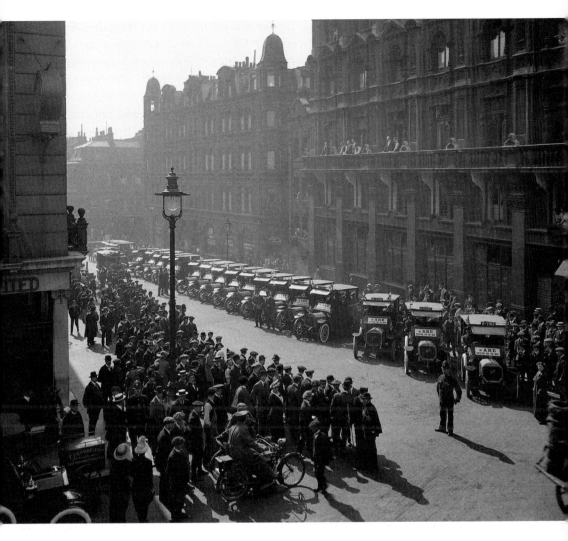

AA Scouts gather in Leicester Square waiting for taxis to take them to sign up for the Army in the First World War. *(English Heritage Archive)*

of 1851 that was sited just behind in Hyde Park. Then you have 'The Bell and Horns', 'The Chapel' and 'The Temple' and 'The Pier'. It's strange to think that our 350-year history is not being preserved by the new guys and gals coming into the trade – who seemingly don't appear to have enough time to visit these taxi shelters – but by Polish builders buying their bacon sarnies and cups of tea! Thankfully they will live on forever because they now have become Grade Two listed buildings and are refurbished by English Heritage.

It was a different ball game for the First World War old boys who ventured out in the dark with their cabs because they were literally putting their lives at risk. By 1915 the German

Zeppelins were attacking London; in fact, between 1915 and 1918 there were 208 airship sorties carried out against the UK. A total of 5,907 bombs were dropped and 528 people, mostly civilians, were killed. The Zeppelins would leave their sheds in Belgium in the late evening, cut their engines and glide across the English Channel on the breeze, arriving silently over London during the night. It's fair to say that the accuracy of the bombing was not very good, but that made it even the more dangerous for the cabbies because the bombs could (and often did) land literally anywhere. The peak of the Zeppelin threat was between 1915 and 1916 when a total of 168 sorties were carried out against Great Britain, killing 115 innocent people and wounding 324 in London.

But in June 1915 came the very first alleged, deliberate bombardment against civilians, when the Gotha, one of Germany's first heavy bombers, scored a direct hit on an East London school killing eighteen five-year-old children. The national papers went berserk accusing the Germans of being 'child-killers from the sky', but in all fairness to the German airmen, the art of bomb-aiming in those days was very erratic and the destruction of London's Docklands was likely to have been their major objective.

But Gotha, the actual name of the bomber, struck a chord among the population and they asked, wasn't Gotha part of the royal family's surname? Indeed it was, the name Saxe-Coburg Gotha came from a long line of German royalty – even Kaiser Wilhelm was part of the family! By 1917, the anti-German feeling was mounting to a crescendo among the British population and King George V took the decision to change the royal family's name to Windsor.

It's hard to believe but at the height of the Zeppelin raids some bright spark in Whitehall decreed that the Albert Memorial in Kensington Gardens should be painted black. His reasoning was that the gold paint on the memorial might reflect on nearby Kensington Palace and make it a target for the German bombers. Was he for real? These guys were literally tossing bombs out of the Zeppelins willy-nilly and they could have landed anywhere, black paint or no black paint! This sombre black paint remained on the memorial for the next eighty years until a £2 million restoration in the late 1990s.

As the British started to organise their Ground Observer Programme they decided to select blind people to act as observers, owing to their acute hearing. It was probably the most rewarding task any such afflicted person has ever undertaken!

The declaration of war against Germany by the Americans on 6 April 1917, because of the sustained attacks by U-boats on American cargo ships, immediately tipped the balance in favour of the Allies. The American troops in Boy Scout-style hats were under the command of General Pershing. He was keen to get on with it – without all of this 'pussy-footing about in trenches', as were his vast numbers of raw recruits. But sadly, both he and his men had no experience whatsoever of the 'killing fields' and in just over a year until the Armistice, he had lost 116,708 dead and 204,002 wounded.

The Germans were slowly being forced back as the war progressed and the Zeppelin raids over London became even more sporadic, especially as the British planes were finding them easy targets. They were painfully slow and just one burst from the plane's guns and they would fall to the ground in a raging inferno.

CHAPTER THREE

Between the Wars

The taxi trade in London was in a perilous state after the First World War. Times were hard for all, the manufacturers, proprietors, 'mushers' and also the journeymen who worked on the meter for the proprietors. The numbers of taxis were some 3,000 down and the battle-weary young cabbies returning after their terrible experiences in France and Belgium, struggled to find a cab to go back to work and earn a few quid for their families. It was alleged by the cabbies' union that the situation was created deliberately by some large garages which were holding back as many as 800 pre-war cabs until the prices went through the roof.

Posing for photographs and seemingly not working in a 1930s east London cab garage. *(LVTA Archive)*

One such South London garage was reported to be selling two a week at inflated prices – the Vinots for £200 unpassed and the Darracqs for £300 passed. The asking price in the case of the Darracqs was nearly as much as when they were new, yet these cabs were nearly ten years old! The cabbies' union complained bitterly to Scotland Yard saying that more than 1,000 discharged soldiers with London cab licences couldn't get employment because of this flagrant scam. But thankfully one large garage did play by the rules and tried to help the demobbed drivers. When the British Motor Cab Co., after suffering heavy losses, decided to discontinue running cabs in 1919, they offered 450 old-type cabs to the returning cabbies at a cheap knock-down price of £120 unpassed – or a bit more on the never-never!

But help was at hand because very soon after, the William Beardmore Motor Co. launched its Beardmore Mk I. The founders were Sir William Beardmore and G.H. Allsworth, the man who supposedly had given Edward VII his first ride in a motor vehicle. Beardmore was a very large engineering concern that made its cabs at Paisley in Scotland. The Mk I was extremely successful and cab historians look at it fondly as

One shiny cab, one scruffy young mechanic. *(LVTA Archive)*

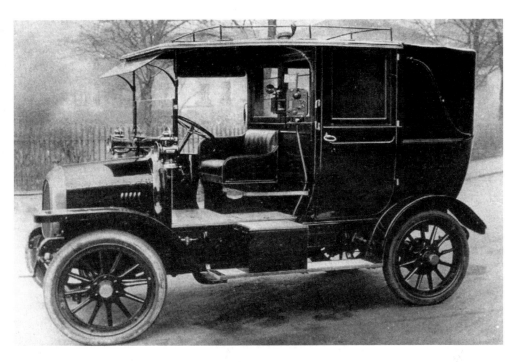

An early Beardmore. *(LVTA Archive)*

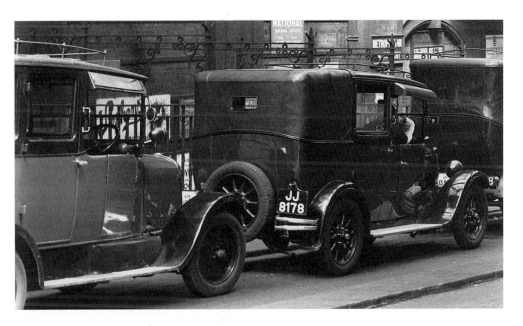

Low Loaders on the station rank at Liverpool Street with a Citroën. *(LVTA Archive)*

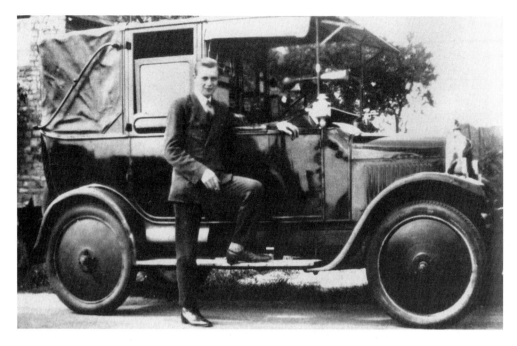

A snappy dresser with a snappy cab (Citroën). *(LVTA Archive)*

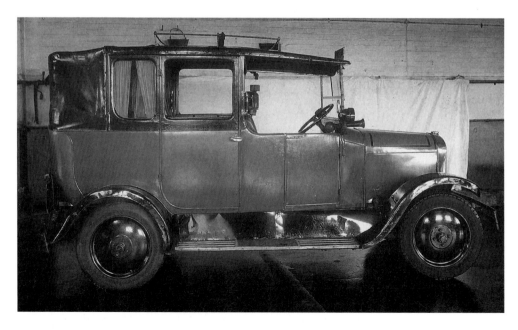

Another of the popular Citroëns. *(LVTA Archive)*

A Cape-bodied 'Jixi' in 1929. This vehicle was introduced into London in 1925. *(LVTA Archive)*

the 'grand old man' of the cab trade. Not only was it an excellent cab, but it was the first London cab to have been designed with prior consultation with the trade and these consultations were continued before designing any new cabs.

Now the manufacturers were up and running and three years after the Beardmore launch came the Belsize, Fiat and Unic, now being produced again in France. The Unics proved to be very popular because they had an excellent back-up service. In 1909 Austin came up with a new design to upgrade their 1907 model and yet another model was introduced in 1910. None of these early Austins survived the Second World War.

Yet another strange fact was that until the Citroën cab appeared in 1923, no other cab had standard fittings for electric lights – apparently the proprietors were quite happy with oil lamps! The 1923 Citroëns, largely owned by 'The London General' – still cursed by its massive Renault debts of 1907 – cost £540, a lot less than the Beardmore. In 1926 the Citroëns were reduced to £495 and a new Unic at that time was £625.

In 1924 Beardmore launched its Mk II – the Super Beardmore, which cost a hefty £625 – without extras. This was an excellent cab and became a front-runner in the market. Until the 1950s Beardmore used the advertising slogan, 'For comfort and speed it's all you need'.

In between times the first Morris-Commercial taxi hit the streets – with only rear brakes, would you believe? But at just £395 it managed to find a place in the market.

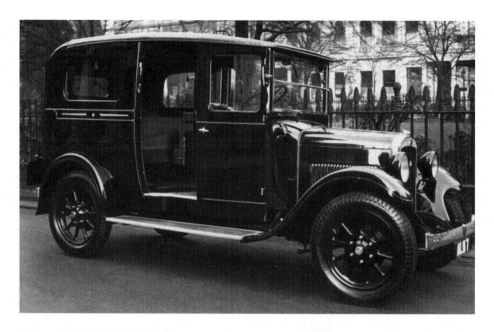

A Cape-bodied taxi. *(LVTA Archive)*

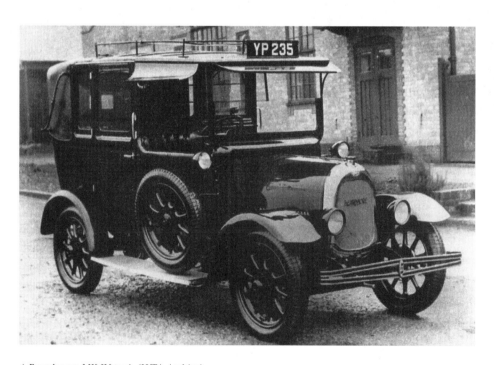

A Beardmore MK IV taxi. *(LVTA Archive)*

The Hyper Beardmore taxi. *(LVTA Archive)*

Again in 1929 Beardmore cornered the market with their MK III 'Hyper' – which basically means 'in advance of'. The Hyper was the very first London taxi to have four-wheel brakes because before 1929, the very strict and old-fashioned Public Carriage Office had said 'no' to the fitting of them on the crazy assumption that, 'Having better brakes would encourage cabbies to drive faster than was necessary or desirable.' These 'old farts' at the PCO must have been living in cloud-cuckoo-land because by 1929 almost every car made already had four-wheel brakes! Many proprietors believed that the Hyper was the best cab so far produced and it was described as, 'elegant, with a roomy interior, four-wheel brakes, a low centre of gravity – and, a low price'!

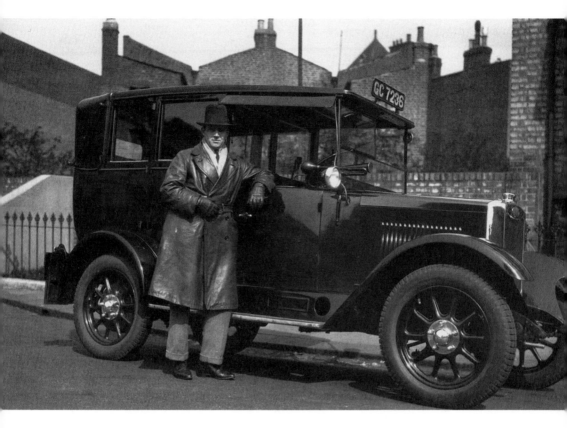

It's not a gangster, it's a London cabbie! *(LVTA Archive)*

Even though the depression of the 1930s was beginning to bite, three more new taxis hit the streets, and these were all designed by the Morris group. The Morris 'G' International was replaced by a smaller version, marketed as the 'G2', but nicknamed 'Junior' and, in 1934 there followed the Morris 'G2S', London's very first six-cylinder taxi. At just £385 it proved to be very good value and quickly became popular with the drivers for its road holding, steering and passenger comfort. Last in the Morris series of the 1930s came the 'G2SW', similar to the previous model but with improved horsepower to the engine.

The most important development of the 1930s was the arrival of the Austin taxi which came to dominate the cab trade. At that time Mann and Overton, a very well known company in the trade, was supplying the French-built Unics, but by the late 1920s their trade was dwindling because these vehicles were old-fashioned and expensive. They scoured the market looking for a suitable replacement and honed in on the Austin Heavy Twelve Four, a rugged and reliable chassis which had proved very successful since 1921. They managed to persuade Austin to adapt the turning circle to the PCO's 25ft requirement. A series of different Austin taxis were produced during the 1930s,

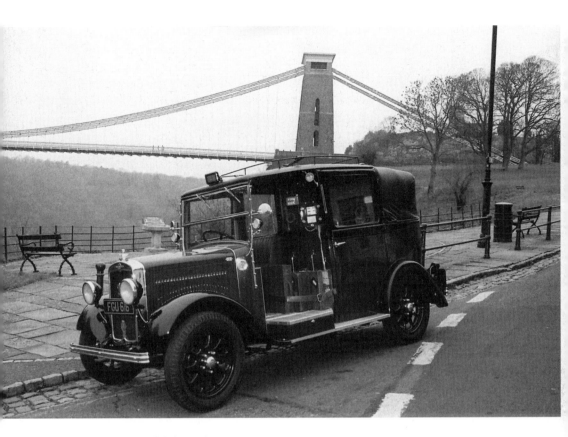

Some old beauties on show. *(LVTA Archive)*

including the famous 'Low Loader', which came to be utilised during the Second World War as fire tenders, ambulances and anti-parachute patrols. Subsequently all previous models were known as 'High Loaders' or in cockney cab parlance, 'Grand Pianos', or 'Upright Grands'. Their final model before the outbreak of the Second World War was nicknamed by the London cabbies as the 'Flash Lot' because of its updated lines, sloping, narrow radiator grille and skirted mudguards.

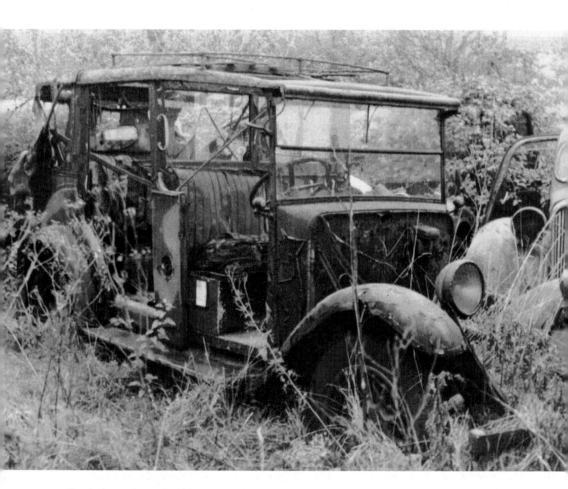

Surely the rank wasn't that slow! *(LVTA Archive)*

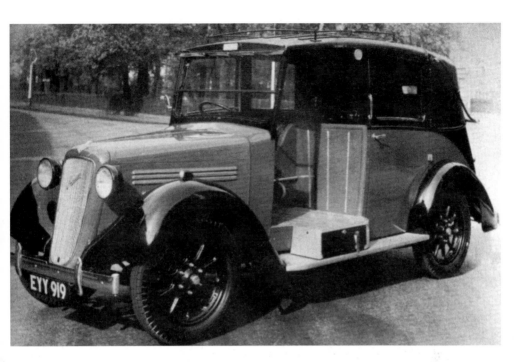

The Austin Flash Lot. *(LVTA Archive)*

Another Austin Flash Lot. *(LVTA Archive)*

Children posing wih Austin Low Loaders. *(LVTA Archive)*

Take your pick from the different models. *(LVTA Archive)*

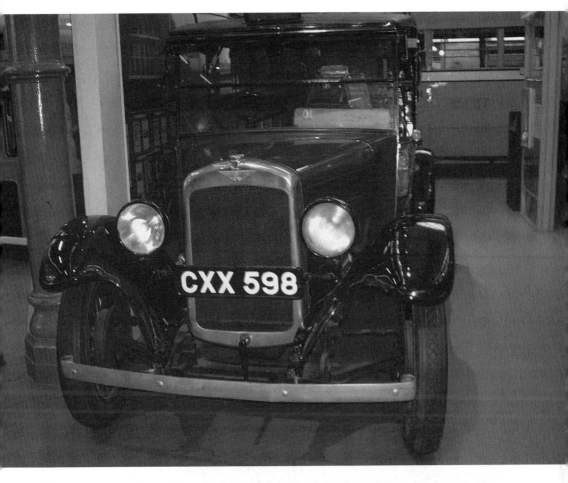

The Napier taxi. *(LVTA Archive)*

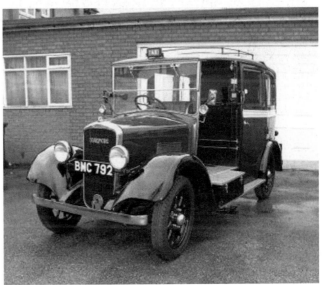

A Beardmore taxi. *(LVTA Archive)*

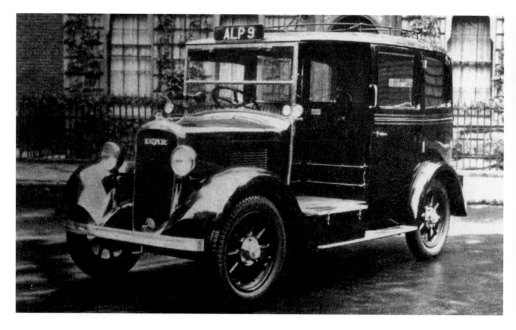

A Beardmore MKIV. *(LVTA Archive)*

Beardmore entered the market again and continued their long run of success in 1933 with the introduction of their 'Paramount' series. Firstly the MKIV 'Paramount', the MKV 'Paramount Ace' in 1936 and the MKVI 'Ace' in 1937. The MKVI 'Ace' was the last of the pre-war series and incorporated synchromesh gears.

When war appeared on the horizon in 1939, production of Beardmore cabs ceased and the company transferred its expertise to war work, making aero-engine parts and guns. Even in those dreadful times Beardmore still had a soft spot for the London taxi trade. They worked closely with the Nuffield Organisation on a prototype Morris Oxford, in order that the London taxi trade would have a new vehicle after the war!

CHAPTER FOUR

London Taxis in the Second World War

Prime Minister Neville Chamberlain chillingly informed the nation on radio in 1939: 'This morning the British Ambassador in Berlin handed the German Government a final note stating that, unless we hear from them by 11 o'clock that they were prepared at once to withdraw their troops from Poland, a state of war would exist between us. I have to tell you now that no such undertaking has been received, and that consequently this country is at war with Germany.' To say that the nation was surprised is an understatement – because only a few weeks before, our Prime Minister had returned from another meeting with Hitler in Munich triumphantly waving a piece of paper and declaring, 'Peace in our time!'

Consequently we were not ready for war, did not possess enough manpower, enough fighter planes and not enough of nearly everything – especially transport. It was the number one priority to discover strong, reliable vehicles that could be easily adapted for the war effort and the robust London taxi fitted the bill nicely. The London County Council requisitioned 2,452 London taxis for war work – out of a total fleet of 6,699, so obviously this dramatic loss of some 37 per cent left many cabbies unable to find a taxi to go to work in. The situation was made worse by the introduction of petrol rationing and a corresponding decrease in takings of 30 per cent.

Because of their sturdy chassis, the Army claimed many taxis for use as personnel carriers – resplendent in their two-tone camouflage netting and even imitation leaves – while ex-service cabbies were recruited to drive the taxis which had been converted to ambulances. The thinking was that if these older cabbies had experienced combat in the First World War, then they wouldn't chicken out under fire. Another valuable asset these old cabbies brought was their intimate knowledge of the back streets of London and the ability to take short cuts and often be first on the scene after a raid. The National Fire Service hired some 2,000 Austin taxis to tow the trailer pumps and augment its fleet of fire engines. Depending on the model, these appliances could pump from 120 gallons per minute, to 900 gallons per minute. It was actually a cabbie who invented the quick-release link to the trailer which made it an integral part of the fire-fighting force. These pumps were called Dennis Reciprocating Pumps and they had to be hand-cranked to start them. When they were running, a lever was pressed which caused a vacuum and the vacuum

pulled the water through. There were two gauges, one showing the vacuum and the other showing the pressure of the water leaving the pump.

The teams operating these makeshift fire engines were mainly taxi drivers, in many cases not fit enough or too old for the Army, but still fit enough to drive. These conscripts were thoroughly trained by professional peacetime firemen before being allowed to attend any sort of fire. They were called the AFS (the Auxiliary Fire Service) and, as in the case of the cabbies driving converted ambulances, because of their knowledge of all the back streets as working cabbies, they were quite often at the scene of a fire before the larger fire engines. The 'mushers' – the owner-drivers – whose taxis had been requisitioned by the

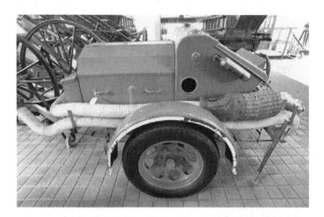

The Dennis reciprocating pump. *(LVTA Archive)*

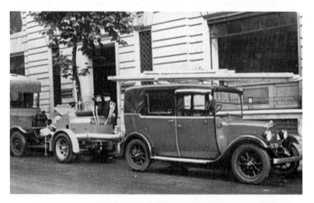

The pump and the taxi fire tender. *(LVTA Archive)*

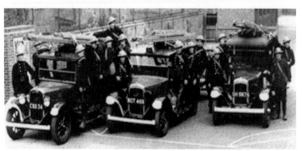

Firefighters posing with their adapted taxis. *(LVTA Archive)*

The ladder on the roof? Sorted! (*LVTA Archive*)

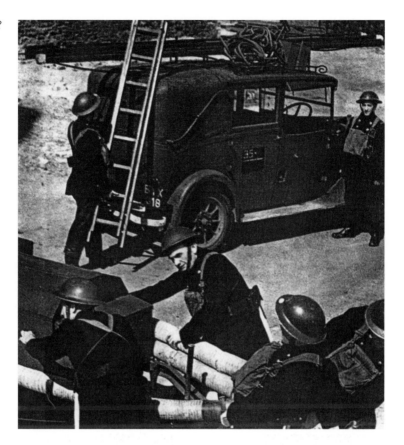

AFS, were paid for driving their own cabs. They received £1 17s 6d per week for the cab and £3 per week for their services as drivers/firemen.

These makeshift fire engines were fitted with all kinds of weird and wonderful equipment. First was the quick-release water pump trailer, with fittings universal to all the other fire-fighting equipment and able to be set up anywhere. The water hoses were stored in the luggage compartment and they carried stirrup pumps that could suck water up from buckets to put out a small blaze. They even carried buckets of sand for smothering incendiary bombs – not the safest of jobs for sure! Ladders were carried on the roof racks normally reserved for passengers' luggage and in some cases, the meter was removed and a small bell inserted, just to warn people of their speedy approach – this was very important, especially during the blackout. The equipment for the AFS drivers was very basic to say the least. Uniforms and safety equipment just weren't available. All they had were rubber boots, overalls, steel helmets, a belt with an axe on it and gas masks. In those far-off days there were no such aids as radios or walkie-talkies, so semaphore was the usual method employed to direct the firefighters to their targets. Because Hyde Park housed a huge magazine for all the ack-ack guns deployed there, in an emergency the complete magazine could be flooded directly from the Serpentine which held some 18,000,000 gallons of water.

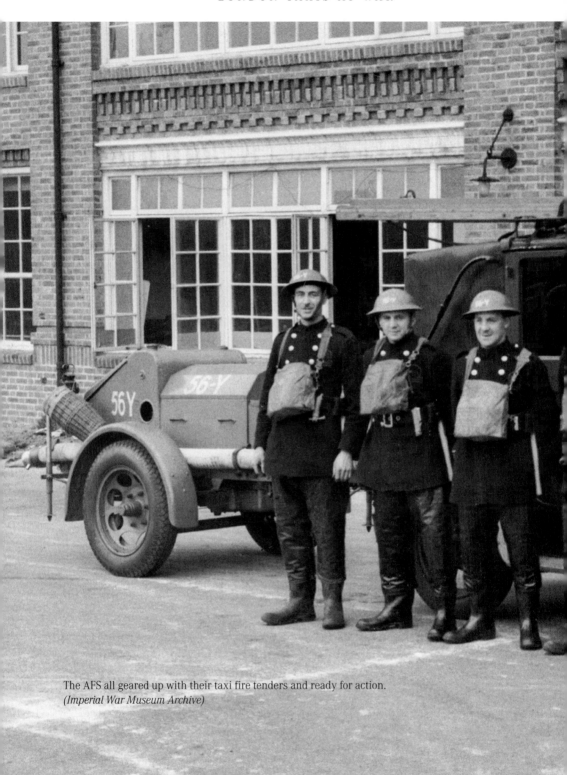

The AFS all geared up with their taxi fire tenders and ready for action.
(Imperial War Museum Archive)

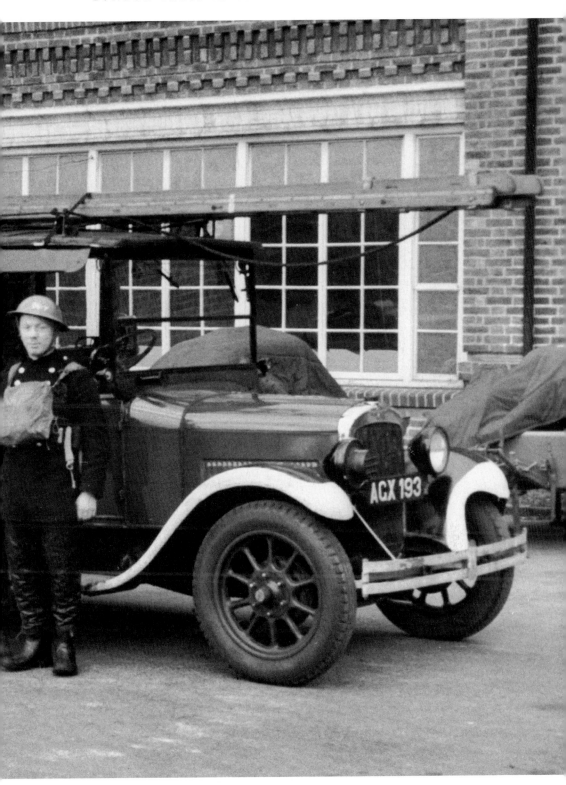

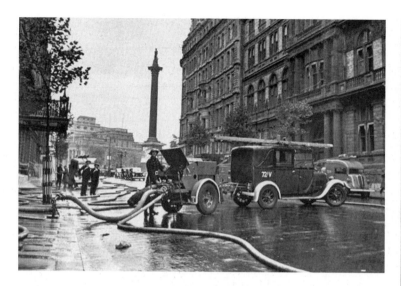

Above: A fireman with an adapted cab and trailer pump near Nelson's Column.

Right: 'Dad's Army' practising with their guns and taxis. 'They don't like the cold steel up 'em!'

There was this great story I read from a soldier who had been deployed just north of Brighton early in the war. All the talk at the time was about a German invasion after Dunkirk and the Army Command had this weird idea of deploying groups of ten soldiers all over the South Coast. Their orders were to continually check the beaches and scour the countryside looking for German paratroopers, who were to be shot on sight. But what on earth just TEN soldiers would do in the advent of a massive German invasion, I really don't know! These units were all armed with a Lewis Gun (a light machine gun), a small searchlight, a sound locator and each carried a rifle and fifty rounds of ammunition. One day soon after, one of the senior officers arrived at their Brighton base in a London taxi, driven by a London cabbie. The Government actually requisitioned some 400 London taxis and deployed them to these units under the grand title of 'Anti-Paratroop Patrol Work'. The army boys were subsequently informed that with a taxi, they were now considered as being 'mobile troops'. This particular taxi was specially designed for purpose. The driver sat in a little section on the right with the luggage platform on the left and at the back the hood could be folded down. Over the top

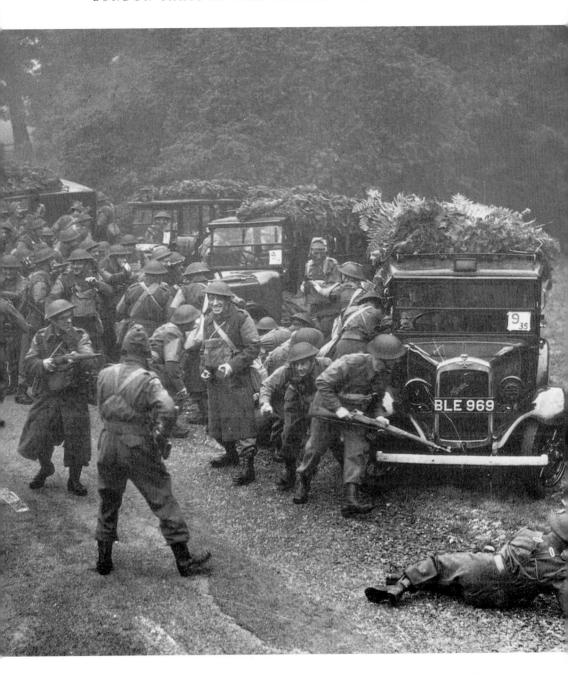

of the driver was a luggage rack and the Lewis Gun was mounted on this to fire forward over the driver's head – hopefully! Later on, when the threat of invasion receded, these 400 taxis were either added to the AFS fleet, which was constantly being depleted in air raids, or returned to the London fleets.

If you start to analyse Britain's totally inadequate coastal defences in the early days of the war, you begin to wonder why on earth Hitler didn't carry out his threat to invade.

Even I often queried this as a boy during my long evacuation to Cornwall as I freely roamed the massive beaches of Perranporth. We London tearaways had no problem climbing over the miles of rusting scaffolding along the beaches that were loosely called 'tank traps'. I remember thinking at the time that if we could quite easily scale them, what a piece of cake it would be for a crack German battalion – especially when faced with the old boys of the Home Guard wielding their broomsticks!

The 'invasion mentality' was very prevalent among the authorities and a police notice was delivered to all cab owners in London – this is the notice.

IMMOBILISATION OF CABS IN THE EVENT OF INVASION

All cab owners should be ready, in the event of invasion, to immobilise their vehicles the moment the order is given. Failure to act promptly would give the enemy the chance to provide himself with transport. It is important that cab owners should understand now what they and drivers in their employment have to do and satisfy themselves that they can carry out the order at any time without delay.

In the event of owners being informed by the police or through the Civil Defence Services that immobilisation of vehicles has been ordered in their area, must take the following steps in regard to all their vehicles.

Remove the distributor head and leads, and either empty tanks or remove well away from the vehicles.

If vehicles are required for Home Guard purposes, special instructions will be given.

IN CASE OF INVASION

Fuel tanks can be emptied through the drain plug if one is provided or, as an emergency measure, the tank can be punctured (e.g. by a large nail) at its lowest part.

Care should be taken that fuel drained from tanks is not emptied where it will flow into drains, otherwise a serious explosion may occur. These things are the least that must be done. It will be all to the good if other readily removable parts of the mechanism are also taken well away from the vehicle.

Where no order has been issued but it is obvious that there is an immediate risk of the vehicle being seized by the enemy, the distributor head or magnets should be smashed with a spanner or hammer and tension heads removed.

Owners of garages and large fleets of vehicles in specified areas may be required to remove stocks of spare parts or parts taken from their vehicles, also they should make provisional arrangements accordingly. As vehicles may be on the road a long way from their garage when an order for immobilisation is given, owners should ensure that drivers are properly instructed as to the correct method of immobilising their vehicles.

Cynics may well say that if it was a highly organised invasion, then surely the invaders would bring plenty of transport with them? But these were nervous days.

As the hostilities moved forever onwards, London taxis were still being restored and used as makeshift vehicles to stow rescue equipment and other various rescue jobs. One man from South London was asked to join the newly formed Light Rescue Squad Woolwich Volunteers. He relates a great story of being taught to drive, then retrieving some old pre-war London taxis from a dump in Crystal Palace. They were ancient Beardmores with the gate-change gears, but the biggest problem was that their batteries were clapped-out and always failing. These were used not only for stowing rescue gear, but he says he used his to carry injured people from a bombsite in Smithies Road to Abbey Wood Hospital where a V1 rocket had killed five people in that particular raid later in the war.

The systematic destruction of Britain's airfields, the planes on the ground and the many radar stations by the Luftwaffe in 1940, was having a devastating impact on the RAF's ability to keep the skies safe. Then Churchill ordered a token bombing raid on Berlin, it wasn't very effective – but a great morale-booster to the nation. Adolf Hitler went into a raging fury because he had boasted to the German people that no enemy bombers would EVER bomb Berlin. Hermann Goering, the head of the Luftwaffe, also lost face with this bombing raid because his regular after-dinner boast was, 'If ever the British manage to bomb Berlin, you can call me Mieira!' In his quest for instant revenge Hitler made his first big mistake of the war by ordering the Luftwaffe to change their successful tactics and start bombing Britain's cities, starting with London. Although this was tragic for the city dwellers, the respite was enough for the RAF to start rebuilding their airfields and getting new planes. Hitler never realised how close he had got to defeating the RAF.

After the Battle of Britain, when our fighter pilots decimated the Luftwaffe squadrons and finally convinced Hitler that we weren't ripe for the taking – not forgetting the threat of the British Navy who had sank some ten major German ships in the two battles off the coast of Norway – all the gang at the famous Biggin Hill airfield were celebrating their 1,000th kill. Vickers, the company who made the Spitfires, threw a fabulous party at the swish Grosvenor House Hotel for the Biggin Hill pilots. All the famous names were present including the celebrated Douglas Bader, Stanford Tuck and the legendary 'Sailor' Milan – plus the lovely ladies from the Windmill Theatre. The story goes that thirty London cabbies volunteered to give all the pilots and their guests a free ride back to Biggin Hill! The boys at Biggin Hill never forgot that kind gesture by the London cabbies and further down the line they responded by inviting the cabbies to a free booze-up on their patch.

The Blitz on London was like a permanent nightmare, I can testify to that as a young kid living in North London. The German bombers were arriving – seemingly unopposed – nearly every night. There were, of course, ack-ack batteries and barrage balloons, but they were only really token defences. From 7 September 1940, they battered London every night for fifty-seven consecutive nights. They dropped an estimated 330 tons of bombs and killed many thousands of innocent people and injured many more. The London Docks in the East End was their primary target in an effort to starve us out, but any main line station would do and, if they had any bombs left, they'd just drop them anywhere in the suburbs on their way back to their bases.

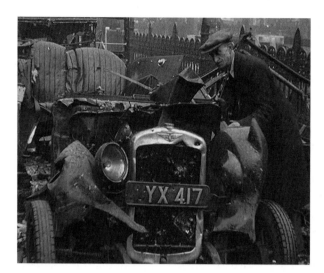

No work for the week, mate.
(Pathé News Archive)

Rumours swept around London during the Blitz that the various council depots were stacked high with coffins. These rumours were in fact correct. In 1937 the Air Ministry had estimated that the probable outcome of some 600 tonnes of bombs falling on the city would result in at least 20,000 fatalities. But thankfully, what the authorities couldn't predict was the many thousands of displaced people who had been made homeless by the savage bombing. So the 600 tonnes dropped on London only caused about one-tenth of the estimated casualties – but still an awful lot of innocent people.

But like any other people with a job in London, the cabbies were forced out to work to get some food on the table for their families. The work on the streets had picked up almost overnight after our boys arrived back home from Dunkirk and the cabbies were doubling their nightly takings. One of the primary reasons for this was that the authorities started to curtail the movements of private cars and many of these car owners started to use taxis as a safer way of getting around. Consequently, without the extra traffic on the roads the cabs could get about their business quicker and do more jobs in the same time. But the extra work for cabbies soon ended and it was back to normal. Their original petrol ration was just 2 gallons for every shift and the old cabs only did about 14 miles to the gallon. So long journeys were not on, a fare to Kensington and then a fare back to the West End was the best way to utilise their meagre petrol ration. Later on in the war the ration was increased to over 3 gallons a shift. It was far worse at night in the Blitz and the blackout, with a driving limit of 20mph until 7.00 a.m. But that's when the best money could be earned because there was a large number of randy servicemen on leave looking for a good time – and maybe a 'good-time girl'. The regular night cabbies knew all the clubs who would cross their palms with a nice gratuity for delivering them some punters and they also knew the whereabouts of all the more generous 'ladies of the night'.

During the war years it was quite a common sight to see a cabbie – accompanied by a copper – dipping his fuel tank in an effort to prove that he had refused a fare because he only had enough petrol to get back to his garage? If he did happen to have more than enough fuel in his tank, then he was well and truly nicked!

When I finally completed the dreaded Knowledge of London and gained my coveted green badge just before Christmas 1962, there were still many mature cabbies on the road who had driven throughout the war. I was always fascinated with their humorous and often tragic stories of their wartime experiences. One of them relates a great story about the site of the old Shaftesbury Theatre that got bombed in the Blitz. Once the rubble was cleared it was used as a car park. Adjacent to this was the Beaufort Club in Lisle Street, which over a period of time became a cab drivers' club where they played billiards and snooker as a break from driving. The wooden hoardings around the car park made it quite a private area and the old, cunning car park attendant quickly realised that all the empty cabs in the West End – and in enclosed surroundings – would make an ideal venue for all kinds of activities. Who knows, maybe for 'the ladies of the night' to put in some extra overtime in the day? Here's how the scam worked. When the cabbies parked up (the site could only manage a dozen cabs) the old boy would ask them how long they would be in the club and promised to clean up the cab before they came back. Imagine the cabbies' delight when they returned and the old boy handed them a sizeable amount of wedge? It certainly beat using your ration of petrol and scratching around on the dangerous and deserted streets! In today's climate of political correctness, the old boy would have been well and truly nicked for procurement and the cabbies would face serious charges of 'living on immoral earnings' and perhaps even lose their cab license.

Many of the stories from wartime cabbies have entered the folklore of the trade today – some tragic, some amusing and others almost unbelievable. The one I like best concerns the cabbie who picked up a guy at Euston station and was directed to Waterloo. Halfway across Waterloo Bridge, the guy asked the cabbie to stop. Suddenly the nearside passenger door burst open, the passenger appeared and raced towards the parapet. Without as much as a backward glance he leaped over the parapet into the icy waters below. The driver got out of his cab and peered into the murky waters, but there was no sign of his passenger. As luck would have it he spotted a War Reserve copper nearby and called him over. After relating the story, the old copper gave the cabbie a funny look and asked sarcastically, 'Did he pay you the fare mate?' to which the cabbie replied 'Why, no.' The old copper smiled and replied, 'then you'd better go in after him!' Sadly, a few days later a body was fished out of the river further downstream.

Still on the subject of Waterloo Bridge, during the war the bridge was being reconstructed and cabs were restricted to crossing the bridge from the south side – with passengers only. Empty cabs were diverted and, if you disobeyed the signs, you were well and truly nicked and your licence endorsed! The old-timers tell me that the famous Bud Flanagan (of Flanagan and Allen fame) actually held a cab licence for a short while. But he got fed up with the job and supposedly chucked his cab licence into the Thames off one of the bridges. In hindsight, a wonderful choice!

Another great story from a wartime cabbie was when he picked up a four-star general who came rushing out of a hotel and instructed him to get to Waterloo station as fast as he could and, 'not to worry about the speed limit.' So our man is hammering down Constitution Hill at a fair rate of knots, only to be pulled over by a motorcycle copper. Suddenly the four-star general leaned out of the window and shouted angrily, 'Get out of the way you blithering idiot, can't you see I'm in a tearing hurry? If you've got any savvy you'd escort me

to Waterloo.' So now the cabbie is following the motorcycle copper with his lights flashing and they reach the station in double-quick time. The general paid him off with an extra large tip after giving him a knowing wink in the direction of the copper! Apparently this general, according to the copper, was heading post-haste to the south coast because he had just received orders that the commencement of D-Day was imminent.

The following story is so far-fetched as to be improbable. But knowing the trade as I do, I suspect it has been expanded every time it's been told and so, as a giggle, I've called it 'Hello Sailor!'

The story goes that a cabbie is working early one Sunday morning and just passing one of those flea-bitten little hotels that proliferate around the capital. Suddenly, out dashes a guy carrying a canvas bag and frantically hails him. After much puffing and panting, he asks to be taken to Victoria station as fast as possible, but even with no traffic on the roads his train had long gone by the time they made it to the entrance.

Now the guy is in a blind panic and tells the cabbie he's in the navy and if he misses his ship, he'll be well in it. 'Could you possibly take me to Dover?' he asked pleadingly, 'I've not got much dough on me but my shipmates will chip in at the other end.' The cabbie thought over his options for a few seconds and decided that this guy was genuine, so he would take a chance on getting paid.

So off they went with no traffic in sight and bombing along at a decent speed down the Dover Road. Now the guy starts confiding to the cabbie, saying how he spent a 'dirty weekend' with his girlfriend and overslept because he'd consumed too much booze.

All dressed up and ready for work. *(LVTA Archive)*

On arrival at the docks, he dashed into the office and started talking to a couple of guys in uniforms, before rushing out again and shouting, 'Do you see that bloody submarine going out of the harbour, well, I'm supposed to be on it and, what's more, it's bloody going to Australia!' The guy dashed back into the office again and told the cabbie to follow him to the liberty boat tied up at the jetty. 'This will get me to my sub,' he said, 'so you can either come with me or I'll send you the money.' Again the cabbie weighed up his options, thinking to himself, if he's going to bloody Aussie, I'll have a long wait for my money. So he decided to park up his cab and go on a boat ride!

After much crashing about clearing the decks and casting off, the rating started up the engine and away they sped in pursuit of the sub, which was quite a way off, but thankfully still on the surface. Much to the discomfort of the cabbie who hadn't been in a boat since taking his kids on the Serpentine at Hyde Park, the water started to get a little choppy as they left the protection of the harbour. The sea spray began to shower the three guys in the boat, but the two mariners weren't bothered in their waterproof gear! Suddenly, the poor old cabbie decided he'd made the wrong decision and he should have waited for a letter from Aussie. So he just turned his collar up and hung on tight!

Then to cap it all, the sky became overcast, the rain began to fall and the boat started to lurch from side to side as the waves buffeted it. Not only that, but the sub seemed to be getting smaller and smaller as the distance between them lengthened. As the mist started to descend, the sub disappeared completely and the cabbie was reminded of what Oliver Hardy used to say to Stan Laurel, 'That's another fine mess you've gotten us into!' But still the sailor held the launch at full throttle, heading for the spot where the sub was last seen, until asking the submariner to take the helm while he dug something out. He rummaged through the bow locker and came up with a signalling lamp, taking a few moments to set up the apparatus and start sending out the flashing light signals. The boat was rocking from side to side and, while the sailor was perched precariously on the bow, all the cabbie wanted was to sit in his warm taxi and get away from this bobbing boat which by now was making him feel a bit 'Tom and Dick'!

The rain was getting heavier, the cabbie was soaked to the skin, but still the signalling went on. Suddenly the sailor shouted, 'About bloody time too!' and through the mist they could see tiny flashes of Morse code coming from the sub. 'What does it say?' asked the cabbie. The sailor deciphered the code slowly and replied, 'WILL HEAVE-TO AND TAKE ON MISSING CREW MEMBER.' That's a result, thought the cabbie, but how's the guy going to get on board and, how will I get my dough?

It took ages for the liberty ship to get close to the sub and the wind was causing a heavy swell with huge waves breaking over the sub's hull. One of the officers high up in the conning tower, dressed in a heavily-hooded duffel coat, started shouting orders to the crew on his megaphone and they started to unwind a coil of heavy rope which had a lasso-type attachment at the end. They threw it out towards the launch, but it missed, then they tried again successfully and the submariner managed to attach it under his armpits. Then the officer gave the order and the submariner jumped, only to come down in the choppy water way short of the sub and disappear under the waves. Luckily he reappeared in a couple of seconds and his mates pulled him on board.

First part concluded successfully, thought the cabbie, now how am I going to get my money? After a quick explanation to the officer, the crew had a whip round, put the dough in a canvas bag and hung it at the end of a long boat-hook. The sailor on the liberty ship managed to grab it at the third attempt. After a quick wave from the officers on the conning tower and the submariner, now drenched to the skin, the sub disappeared once more into the mist.

As the liberty boat headed back to the harbour the sailor said the sub was sending another message and sure enough, when the cabbie looked back, he saw the dim, twinkling flashes coming from the direction of the sub. The now-drenched cabbie was intrigued and asked the sailor what the message said. He replied, 'It says, THANKS FOR YOUR HELP IN RESTORING LOST CREW MEMBER. BEST WISHES AND GOOD LUCK – END OF MESSAGE.'

After a nice hot cup of tea and a tot of rum, the cabbie finally started to dry off and made his way back to London thinking to himself, while chuckling, never again mate!

The wartime cabbies had to endure bombs crashing down, unexploded bombs in the road and raging fires – not counting the pea-souper fogs and the blackout that made driving a nightmare. Okay, so many of them wore their tin helmets on duty, but a tin helmet is not going to stop a bomb blowing up your cab is it? So the old hands out on the streets at night would carefully judge the bomb patterns in any raid and make a beeline for the nearest air raid shelter if they got too close.

A group of cabbies parked up on the rank at Leicester Square for a break one night during a heavy raid, before going down to the air raid shelter, and must have counted themselves extremely fortunate. There was a tremendous explosion outside and when they emerged, the blast had totally destroyed every cab parked on the rank.

But come the latter part of 1941 things were about to change radically for the English and, in particular the London cabbie. A major new ally would be joining our lone fight against the might of the German war machine and many thousands of their troops would flood London – with their pockets bulging with dollars!

The Perils of Driving in the Blackout

Contrary to the popular belief that the blackout only came into force after the massive air raids by the Luftwaffe on London, the government actually, with shrewd foresight, imposed this on 1 September 1939 – two days before the outbreak of the Second World War. Indeed, as early as July 1939, Public Information Leaflet No. 2 (issued as part of the Air Raid Patrol training literature) warned civilians that 'everybody would need to play their part and ensure that Blackout regulations were properly enforced during the Blackout periods.'

These white-helmeted ARP wardens became notorious during the Blitz and God help you if your house was showing a chink of light. There would be a loud banging on your street door and shouts of, 'Put that bloody light out!'

The Air Ministry had already warned that Britain would be exposed to regular air attacks which would cause high civilian casualties and mass destruction from enemy night bombers. Mind you, it wasn't exactly rocket science that had brought this response from the Air Ministry, because only two years earlier, the German Condor Legion of the Luftwaffe had decimated the town of Guernica in the Basque region of northern Spain during the Spanish Civil War. It was plain for all to see, the Germans were launching their doctrine for future Blitzkriegs.

The blackout imposed on all civilians in all cities was absolute. No chinks of light, no see-through curtains and no car headlights. Even the red glow of a cigarette was banned as Britain was plunged into darkness for the duration. It was widely agreed that blackout controls would make it more difficult for the enemy bombers to pin-point their targets. The theory behind the blackout scheme was excellent, but in practice it caused absolute chaos on the roads. Motorists were instructed that interior lights were banned and to use a slit mask (comprising of three dark horizontal slits) for the headlights. Indicators had to be dimmed and the light from the rear lamp reduced. Consequently, because the lights were so dim and pointing downwards, the poor old motorists couldn't see any direction signs. Car accidents increased alarmingly during the 'Phoney War' (the first year of the war when nothing happened) and the number of people killed on the roads almost doubled, including many poor souls who were drowned after falling off bridges. The King's Surgeon, Wilfred Trotter, wrote a scathing article for the *British Medical Journal* where he pointed out that 'By frightening the nation into Blackout regulations, the Luftwaffe was able to kill some 600 British citizens a month without ever taking to the air, at a cost to itself of exactly nothing!'

As for the poor old London cabbie trying to earn a living in the blackout and the bombs falling out of the darkened skies, it was pretty grim. These hardy souls were nicknamed by many as 'Blitz Drivers', because they worked when all other forms of transport had ceased. One national newspaper dubbed them as being members of 'The Suicide Club'. There was total blackout on the streets, no lights from houses, offices, factories, street lamps and, even the traffic lights were dimmed. The only traffic allowed out on the streets at night were essential vehicles like fire-engines, ambulances, police cars, buses, priority delivery vans, and, of course taxis. The cabbies were even forced to remove their illuminated 'For Hire' signs and cover up the blue light next to the meter. It all became a bit farcical when the authorities permitted buses to retain their illuminated destination boards, four times the size of the taxis' 'For Hire' signs!

The night cabbies had to negotiate bomb damage strewn all over the place, huge holes in the roads with rows of red lamps warning of the danger – but no visible signs telling them what side they could safely pass. Then there were those many steel gratings with the merging clouds of white vapour – almost ghostly and eerie. The street signs were almost non-existent, some had been obliterated by bombs and others covered with sacks. There was no uniformity with many of the remaining street refuges, some obelisks having a white cross, others a square light – or a red light – and often, no light at all. Some lights were positioned at the bottom of the post, some in the middle and some on top! According to a High Court ruling of the day, 'the lighting of refuges is not compulsory.' Because

of the increasing fatalities and many more people being injured by tripping up, falling down stairs or bumping into lamp-posts in the blackout, the authorities were forced to come up with some innovative and novel ideas. The bumpers, wings and running boards of cars and taxis were all to be painted white so that they could be seen better in the pitch darkness. White stripes were painted on the roads and on lamp-posts and people were encouraged to walk facing the traffic. People were told to wear anything white when they were out at night, whether it be white hats, scarves or suits and dresses. Another strange edict issued from the authorities was that 'gentlemen were advised to leave their white shirt-tales hanging out, so that they could be seen by cars with dimmed headlights!'

But the 'Blitz Drivers' carried on regardless and many of these wartime cabbies who were still driving when I arrived on the London cab scene in the 1960s relate some wonderful stories. They all agree that the 'Cat's Eyes' were by far the best invention to come out of the blackout. These two small pieces of glass – like marbles – were encased in a square block with a rubber insert then fitted into the centre of the road some 20 yards apart. The driver was able to follow a safe path because his dimmed headlights illuminated the cat's eyes and, when the wheels passed over them, they simply sank back to the road level and sprang up again – surely one of the best inventions of the Second World War. Another ploy the cabbies used to help them through the blackout was to follow the tram lines. This was fine if it was a single track – they would know they must be heading in the right direction, but the problem arose when they reached a major tram junction like Nags Head in North London. Then it was a case of 'heads I take the left one, or tails I take the right one' and,

Maybe the cabbie has gone on a nature walk? *(LVTA Archive)*

many a cabbie must have finished up in Holloway Tram Garage! Another cabbie got a fare from one of the posh West End hotels and was directed to Kensington, but after a while the driver got completely lost in the darkness. So, would you believe, the gentleman got out of the cab and walked slowly in front peering for any road signs and directing him accordingly. This he continued to do until they finally reached his home, but when he asked the cabbie how much the fare was, the driver replied, 'How can I possibly charge you anything when you've walked most of the way?' The punter was adamant that he pay the fare because he said he had enjoyed their little experience!

The maximum speed permitted in the blackout was 20mph and finished at 7.00 a.m. each morning, but the local coppers took great delight in nicking cabbies for exceeding the speed limit – I say cabbies because possibly they were the only vehicles still left on the roads at that hour. Their speed traps were nothing like today's radar-operated traps with what we cabbies call 'a hair dryer'. They would hide behind street shelters or emergency water tanks and time a vehicle from a certain spot and, if the vehicle reached their next marker in a specified time, then they'd jump out and nick you. A £10 fine and an endorsement on your licence made it an expensive mistake!

Out of all the many stories I've read about the wartime cabbies, my particular favourite is an article supposedly written by a journalist in a national newspaper. He took a trip in a London taxi during the blackout and asked the driver if he found it difficult. The cabbie replied in a heavy cockney accent, 'Naw, it's a piece of cake, guv'nor. If you whacks a push bike you is too far left, but if you whack a bleedin' great bus, you is too far right, easy innit?'

'This IS Regent Street, Guv!' *(LVTA Archive)*

As the war progressed and the blackout became even more severe, suddenly the cabbies noticed an increase in their takings. Yet again the authorities started to curtail the movements of private hire cars – especially the 'Help Your Neighbour' scheme, which allowed you extra petrol if you were helping to assist your neighbours by transporting them somewhere. But this became a bit of a scam and the number of cars licensed, which had been diminishing, suddenly doubled in a short space of time as nearly every car owner suddenly felt a great desire to help their neighbour! Petrol was short, so the authorities clamped down. Private motorists were not permitted to drive in the dark, so they looked to the cabbies as their only way of getting around in the blackout. It made sense to hail a cab and hopefully let the driver get them home safely.

Prior to the advent of the dreaded paparazzi, celebrities had always used taxis and some of the old cabbies driving during the Second World War relate stories of picking up people like the famous film stars Clark Gable, Tallulah Bankhead, Charles Laughton and his wife Elsa Lancaster, Vivien Leigh and Laurence Olivier. The old drivers reckoned that George Robey was the best tipper – often giving 'double-bubble' – while the other 'George', one George Formby, was so tight that they'd chuckle and say, 'his arse used to squeak when he walked!' The ballerina Margot Fonteyn often used to take a taxi to the Covent Garden Opera House, while Jack Hulbert and his wife Cicely Courtneidge, who lived in Mayfair, were regular wartime cab users. Even the famous writer George Bernard Shaw was a cab rider.

The blackout was bad enough for the cabbies trying to earn a crust at night, but even their daytime brethren were almost blinded by the horrible yellow fog that suddenly enveloped the capital on a weekly basis. This thick fog was particularly dense alongside the Thames and around the dock areas in the East End and the chirpy Cockneys nicknamed it a 'Pea-souper'. The wartime cabbies tell me that this fog made you lose all sense of direction and they'd often find themselves even going the wrong way around the Queen Victoria Memorial. At other times weird and scary silhouettes would suddenly seem to appear in front of you as if you'd run someone over, forcing you to slam on the brakes. But even with the brakes on, because of the swirling fog, you still had the weird sensation of free-wheeling. Many cabbies pulled up until the fog lifted slightly. It was only after the authorities banned the use of coal on household fires in the late 1950s that this yellow fog, which killed many thousands of Londoners with chest complaints, finally lifted.

CHAPTER FIVE

The Yanks Arrive in 'Blighty'

Ever since the First World War most people in America firmly believed that any future conflict in Europe was none of their business. They had adopted a pacifist role, which was echoed by the majority of their politicians. But after constant pleadings from Churchill, President Roosevelt had been secretly supplying Britain with many vital war supplies.

America's pacifism was rudely shattered on 7 December 1941 when Japanese bombers and fighters, taking off from the unseen aircraft carriers out at sea, launched a merciless attack on the American Pacific Fleet tied up in Pearl Harbor. I need not describe the utter carnage that followed as it has been well documented over the decades. But it did signal the entry of this mighty nation into the Second World War.

It wasn't too long before the American military were seen in their thousands around the tourist hot-spots of London and not very long before they had set up their own forces' clubs organised by the Red Cross. Rainbow Corner, on the junction of Piccadilly and Shaftesbury Avenue, was used mainly by officers and The Stage Door Canteen, a little further up Shaftesbury Avenue, was for other ranks. The American troops would all gather here both day and night to enjoy a free coffee and a doughnut and a chat to their buddies. Drinking alcohol was strictly forbidden, but the GIs got around this by stocking up with booze at the PX – the American equivalent of the British NAAFI. Subsequently, the area around Piccadilly at night started to become a bit riotous, with the 'good-time' girls in abundance. This in turn attracted the attention of the American military and became the prime target for the 'Snowdrops', the American Military Police who got their nickname because of their white helmets, white facings and gaiters. To my recollection these snowdrops were nearly all coloured guys and, because of the racial taunts they had had to endure back home, it probably gave them great pleasure to admonish the drunken GIs with their batons before bundling them into the white jeeps!

One wartime cabbie tells the story of having some aggravation with five Yanks in his cab who wouldn't pay the fare when he dropped them off in Piccadilly. As luck would have it there was one of those white jeeps parked opposite, full of military policemen built like brick outhouses. He caught their eye and they all swaggered across the road asking what the problem was. The cabbie only wanted his fare and to be on his way, but not with these guys. They dragged the five boozy Yanks out of his cab and started beating them with their white batons before tossing them into their jeep. These guys were in deep trouble back at the military nick!

Low Loaders ranking up at Liverpool Street station. *(LVTA Archive)*

But this was boom-time for the London cabbies, the GIs had plenty of dough. The average GI was earning around $21 a month, which converted to £5 5s – more than twice what the British Tommy could earn. The lowest ranking American officer could command a monthly salary of $90 – plus another $30 if he was a flyer – so they lived like lords and dined at the swankiest restaurants. Many of the Yanks made extra bucks by flogging illicit booze and ciggies they had purchased at the PX. A carton of cigarettes at their PX cost a measly $2 and could be sold on for £20. Even a bar of soap that cost almost nothing at the PX, could be sold on for between $4 and $8! But the Yanks were extremely generous and the cabbies were often trebling their normal nightly takings, so you couldn't really blame them for preferring to pick up these generous GIs instead of the mean old wealthy English toffs! The situation got progressively worse when the odd cabbie informed the gentry politely that they weren't available for hire – often with genuine excuses. This was usually followed by the sarcastic remark, 'I suppose you are waiting for an American?'

The continuing lack of cabs that the gentry had enjoyed for so long reached such a fever-pitch that questions were even being asked in the Houses of Parliament – coupled with many, often false accusations that the cabbies were fleecing the Yanks. But letters sent to the various newspapers vigorously denied those accusations and defended the cabbies to the hilt. One to *The Times* from Dorothy Black of The International Sportsman's Club stated,

> Sir, when the handing out of gallantry awards is finally made, I hope the London taxi-driver will not be forgotten. Invariably cheerful, invariably there when wanted – both night and day. He will take you anywhere and appears to have no thought at all for his personal safety. Post offices close down, banks cease to function, but after the crash of the bombs, comes the starting up again of the taxi's engine.

Another to the *Daily Telegraph* from the famous C.B. Cochran said,

> Does any class work under greater difficulties than the night taxi-drivers in London? I doubt it, and yet they are subjected to abuse and complaints which, if investigated, very often disclose unreasonableness on the part of the would-be hirer. I would like to record that I have not experienced a single case of rudeness, attempted extortion, or unwillingness to carry me when it has been possible. On the contrary, I have been treated with courtesy and real kindness on several occasions.

Oliver Stewart, writing in the *Tatler* said, 'I think that most Londoners will join me in paying tribute to the taxi men. At many times they are the only ground transport that keep at it – bombs or no bombs.'

The United States Army authorities in London said, 'The number of complaints against London cabbies is so small and not more than one per cent of the dealings their troops have with cash transactions are found to be questionable.'

So ranking up outside one of the American forces' clubs at night – whether legally or illegally – was usually a good earner for the cabbies. The odds were his American punters might want a late-night drinking club – who bunged the cabbies – or a long trip to his base in the suburbs – or farther out in the country. One wartime cabbie tells a great story of

picking up an American guy on the Savoy taxi-rank and being asked the price of the fare to Brize Norton, which was way out in the sticks. They agreed a price and off they went, but the cabbie didn't quite like the look of the American guy because he had a big gash on his nose as though he's been in a vicious punch-up. When they reached the camp the guy said he needed to go inside to get some money and that he wouldn't be a minute. After a long dwell, the cabbie realised he'd been 'bilked' and no way was the guy coming back. Now he was left with two options, 'wipe his mouth and swallow it', as we say, or go inside to see the guv'nor and have a good scream-up. So he decided to take the second option after being bilked because he had the right needle!

He was shown into the CO's office by a giant military policeman and proceeded to tell his story to the base commander, but the guy detailed to find the culprit returned saying there was no trace of him. Suddenly the cabbie remembered the guy telling him that he'd been in hospital with some leg problems and needed to be back by late evening. So, a quick phone call to the hospital and suddenly the nervous bilker was marched in. The officer wanted to put him on a charge immediately, but the cabbie, actually feeling sorry for the guy said that he didn't want to cause any trouble and all he wanted was his legal fare. This he received very promptly – as well as a profuse apology to boot! The cabbie couldn't stop grinning about the incident on his long way home, knowing full well they would be throwing the book at this guy!

Or maybe the Yanks were looking for a good-time girl – who also crossed the cabbie's palm. The going rate for 'services rendered' varied from district to district – with one of the Soho ladies maybe asking for 10s or so, and a Mayfair lady wanting in excess of £3! Even when I was doing night work in the early 1960s, this sort of practice was still commonplace – and a good earner – only in those days it was a request from the 'ladies', 'Once around the park, darling.' Whatever decade, whether it be the 1940s or the 1960s, the police frowned on these practices and were very quick to nick the cabbie for 'procurement'. But let's try to think reasonably, if a punter requires a certain service from his cabbie, then surely it's the cabbie's duty to try to provide it? The fact that he got a bung for delivering his punters to certain venues was simply the rub of the green!

The American troops visiting London on leave were, by and large, welcomed by most cabbies during these hard times. They had plenty of cash and also tipped well, but some of them had a problem when under the influence of the demon drink. Many of these young GIs were of the opinion that this was possibly their last look at life so, sod the damned rule book, they were going to make the most of it! According to the wartime cabbies some of the strokes the Yanks pulled were unbelievable. Next to the Rainbow Club in Piccadilly were those frosted glass inserts on the pavement that allowed light into the cellars below. So, as a protection for these lights, a pile of sandbags were placed on top, but sandbags are notorious for sagging in a constant downpour, so they were boxed in. Then enter the ladies 'on the game' – plus some boozy Yanks and hey presto, the sagging sandbags had, as if by magic, become slightly damp beds! The mere fact that there were coppers standing nearby didn't matter one iota, these were grim days and people got away with murder.

As 1942 dawned, many of our Army boys – plus a fair number of Londoners – started getting annoyed – and even jealous – of the GIs' lifestyle. Someone in the media thought

Ranking at King's Cross station. *(LVTA Archive)*

up a rather spiteful saying that seemed to strike a chord among the cockneys. The Yanks were accused of being, 'Overpaid, over-sexed and over here!' Some over-zealous neighbours resented the fact that a pretty, young married woman living next door often used to go to the American dances. Okay, so her husband was away in the forces, but loneliness is very sad and there's nothing like companionship to cheer up one's spirits. But human nature being what it is, these casual meetings with handsome GIs at dances would quickly develop into a passionate relationship and, by the time the old man returned home, the pretty young wife may have flown the nest! I believe the rate of divorces after the end of the conflict was higher than it had ever been.

CHAPTER SIX

Buzzbombs and Doodlebugs – But Still Plying For Hire

The German bombers were slowly but surely being forced back by heavy losses due to the British perfecting their advanced warning systems – including early radar against the aircraft and sonar for the fight against the U-boat threat. Now it was the turn of the German cities to suffer night after night of deadly, incessant bombing raids.

Hitler realised the tide of war was turning against him and decided to call in Wernher von Braun, the brilliant scientist in charge of his rocket programme. This was his last throw of the dice in an effort to force the Allies around the negotiating table. Hitler wanted a terror weapon that would frighten the life out of the Allies and von Braun quickly gave him just that – with the aid of thousands of slave labourers from the concentration camps. This was the V1 – the 'V' stood for vengeance – a self-propelled bomb loaded with explosives and with a timing device that cut the motor over the target city. Anywhere in the target city would suffice, just as long as it terrorised the population of innocent civilians.

The V1 production was transferred to Peenemunde, a deserted location on the Baltic Coast and around 9,250 were targeted at London, but fewer than 2,500 got through. The V1 had an Achilles Heel because it could only fly in a straight line with a maximum speed of 400mph and proved easy meat for the young fighter pilots in their new Meteor jets. They shot down some 2,000 V1s and would often come alongside, nudge their wings to make them change course and hopefully crash into the deserted countryside. The anti-aircraft batteries shot down another 2,000 and the barrage balloons managed to down 300. Sadly approximately 2,500 V1s did get though to London and resulted in 6,000 civilian deaths and many hundreds more injured.

With D-Day fast approaching, Hitler launched the fearsome V2, the very first rocket to be used in the war. This flew above the speed of sound and there was simply no defence against this weapon. Around 1,000 were fired – even though the RAF successfully bombed their launch pads regularly. But the cunning Germans created a very effective mobile launcher that could be secreted in the forest and fired at will. In November 1944, one of these V2s landed in the heart of New Cross killing 160 innocent civilians, but inevitably, the successful invasion of Europe saw these launching sites being wiped out – but only in the nick of time, because von Braun and his team were in the latter stages

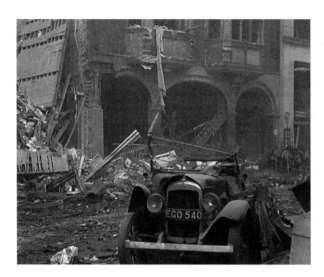

I knew I shouldn't have parked there. *(Pathé News Archive)*

of producing the A10. This was to be the very first long-range, intercontinental ballistic missile with a massive warhead, capable of reaching and decimating, every American city on the Eastern Seaboard some 3,000 miles away, or any other given target in its range.

But the faithful London cabbies carried on working right through the Doodlebugs – just as they had carried on working through the terrible Blitz. The V1s weren't too bad; at least they could hear the dark, growling sound of their engines – almost like a sports car with a dodgy exhaust. Then they'd look up into the cloudless sky and see the red, fiery exhaust spitting out from behind the dark shape. The problem came when the dark, growling engines cut out and it started to spiral down, that's the time when they jumped out of the cab and dived into the nearest air-raid shelter.

Some of the wartime cabbies laconically relate frightening tales of missing death by literally seconds in the face of these flying bombs. One cabbie was heading for his garage in Shoreditch when he heard the unmistakable sound of a flying bomb almost overhead. As he passed the junction of Chancery Lane and High Holborn, the V1's engines cut out and there was an almighty explosion nearby. The following day he heard the news that the Doodlebug had landed on the old First Avenue Hotel – just one street away from his route – killing all the people inside. The same cabbie also tells the story of missing a flying bomb by just 60 seconds. As he went round the bend in Cheapside, near St Paul's Cathedral, he was stopped by a policeman and told that one had dropped just around the corner. Then he saw the smoke, dust and debris rising from an office building some 300 yards away in Old Jewry, near the police station.

I recall chatting to Bert Sheehan an old wartime cabbie many years ago. Now Bert and I were closely connected to the newly formed Licensed Taxi Drivers' Association (LTDA), in fact we were probably founder members. Bert was a lovely man, a South Londoner through and through, he had a rather tatty grey beard and wore spectacles. But behind those spectacles were sparkling blue eyes that always had a twinkle. I'm told he was also a bit of an expert on the gee-gees. Bert tells the story of his wife working at the very posh

Oakwood Court, just west of Earls Court Road in Kensington High Street. She heard this almighty explosion caused by a flying bomb and looked out of the window to see that it had landed right on top of Lyons Corner House down the road. She rushed down to see if she could help only to be confronted by rows of dead laying out on the pavement. Sadly, one of them was a young girl who worked with her.

Another tragic story told by a wartime cabbie was about heading towards Birdcage Walk and the Guards Chapel – close to Buckingham Palace – on a bright and sunny Sunday morning in 1944. The driver had two ladies in the back and although the air raid sirens had already sounded, it didn't stop the cabbies from taking a chance and carry on working – maybe with a few 'Hail Marys' thrown in! As he neared the chapel, suddenly there was a massive explosion just to his right, followed by a rush of hot air. The cab was literally lifted off the ground and thrown onto its side, landing in St James's Park. A V2 had exploded very close by. Within minutes the rescue services were on hand and the two lady passengers and the cabbie were shipped down to St Thomas's Hospital just across Westminster Bridge. Apart from a few scratches and bruises they were all fine and able to leave after being treated. But sadly, as they discovered later, the rocket had landed directly on the Guards Chapel killing all of the two hundred-strong congregation – plus the seventeen guards who were on duty.

Another wartime cabbie relates the humorous story of travelling over Holborn Viaduct, heading for Liverpool Street station, with four American airmen in the back. Suddenly, whoosh! there was an almighty explosion to the left in Smithfield meat market. A V2 rocket had come down just a couple of hundred yards away and all the windows and frames from the surrounding buildings came crashing down, showering the cab with glass and dust. The taxi wobbled from side to side with the blast, so the cabbie immediately put his foot down to escape from the mayhem.

When he finally arrived safely at Liverpool Street station, one of the airmen who was paying the fare and looking decidedly shaky – as they all were – said, 'Jeez, it's safer in a God-damn plane!' The last guy out started to walk away like Groucho Marx and his buddies asked him what was wrong, to which he replied, 'I've crapped myself!'

I was a young boy growing up in North London during the Blitz and with the constant threat of V1s and V2s. Now, as an adult, I can relate to what these wartime cabbies had to endure. With my enquiring mind I often used to ask these old boys what they thought was the worst, the Blitz or the V1s and V2s? Most of them would grin and answer laconically, in a broad cockney accent. 'It didn't matter what was coming down, kiddo – just as long as you weren't under the bleedin' thing at the time!'

With the dawning of 1944 things were starting to change for the London cabbie because now, every fare they carried seemed to be heading for one of the main line stations that served the south coast. Many of the punters were military officers – mostly army and navy – but many more were important-looking civilians in bowler hats. The cunning old cabbies – with a nose for sniffing things out – just knew something big was afoot, especially when the American military suddenly disappeared completely from the London streets! Even the 'ladies of the night', who were used to having a brisk trade, were forced to drop their prices because punters were very few and far between! In effect, the only

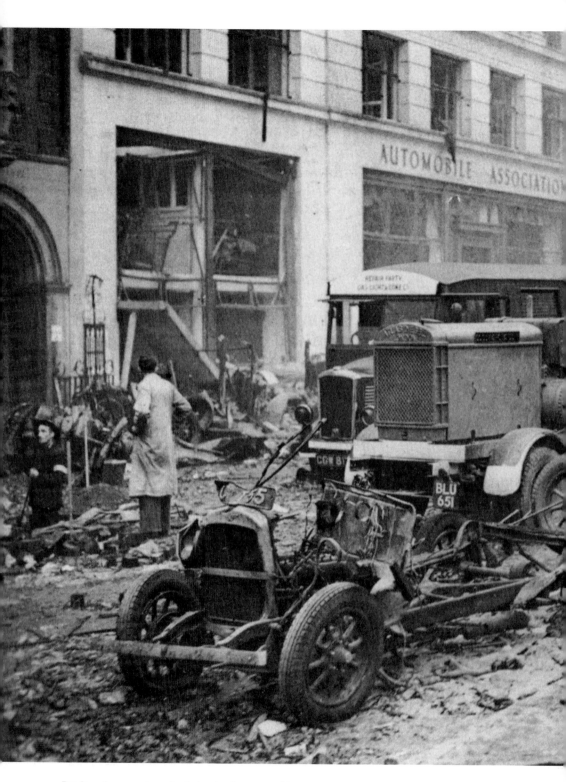

Don't park your cab on the Leicester Square rank!

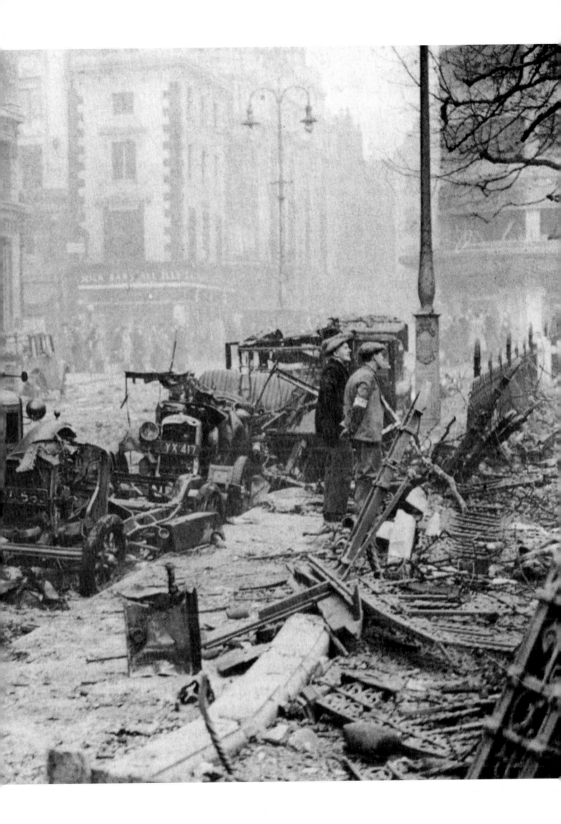

military personnel to be seen in the whole of London were staff officers heading for the War Department in Whitehall.

Operation Overlord, the plan for the invasion of Europe, was underway. This entailed the massive task of assembling 5,000 ships and landing craft, 600,000 tons of equipment and 200,000 vehicles – not forgetting many army and airborne divisions. The military had taken over most of the towns and villages on the south coast and many thousands of locals were moved out to temporary accommodation. The byword of the day was 'secrecy' to keep the Germans guessing when and where the landings would take place. In fact the Allies went to great lengths to fool the Germans into thinking that the crossing point would be on the shortest sea route, Dover to Pas-de-Calais. The top-ranking American, General Patton – a high-profile guy known for having silver six-shooters on his belt – was posted to Dover with supposedly his crack regiment of tanks. But these 'crack tanks' were in effect only cardboard cut-outs hidden underneath netting. The German 15th Army protecting Pas-de-Calais were so completely fooled that even after D-Day, they convinced Hitler not to move his Panzers to Normandy saying it was just a diversionary attack with the main thrust coming from Dover!

The success of the D-Day landings and the subsequent removal of the Nazi threat from Europe have entered the annals of history and will always be remembered. It was well planned by General Dwight Eisenhower and his team, but it was the bravery of the soldiers, sailors and airmen who made it succeed.

CHAPTER SEVEN

VE Day in London

The wartime cabbies tell me that you needed to be in London on 8 May 1945 to even get a feel of what VE Day was like. After nearly six years of war with rationing, food shortages – plus other shortages of nearly every kind – the day had finally come for each and every person to let their hair down and have a good old-fashioned knees-up. The capital's residential streets organised their own parties and all the goodies that had been hidden for years suddenly saw the light of day. Sweets, chocolates, home-made cakes, trifles and jellies of all flavours appeared on the massive tables. Many of the local guys who worked down the Royal Docks or the fruit and vegetable markets like Covent Garden or Spitalfields, managed to supply various fresh fruits – including bananas that the young kids didn't even know how to eat, simply because they'd never seen one before! But how these guys managed to get hold of all these exotic fruits, nobody knew – and nobody cared! Sadly, this was a one-off party because rationing continued right though to the late 1950s, encouraging a burgeoning black market and a spate of petty thefts. I can vouch for the fact that during the late 1940s and early 1950s, just about everyone I knew was on the 'hey diddle-diddle'.

But this was a boom time for the London cabbies with a massive influx of people coming into the capital to celebrate. It is said that one million people celebrated D-Day in London, with many thousands thronging Trafalgar Square and outside Buckingham Palace cheering the royal family and our wartime hero Winston Churchill. We Brits are a funny lot aren't we? Without the shrewd judgement and bulldog spirit of Churchill we probably could have lost the war. Yet just a few months after being hailed a hero, he was suddenly called a 'warmonger' during the General Election and was swept aside by Labour's Clement Attlee!

It was like a madhouse for the cabbies out on the streets and all the main line stations were frantically busy with thousands of our boys returning home – all seemingly within days of each other. So the ever-resourceful cabbies concocted a profitable scheme to earn some extra dough for themselves! This was known in cab parlance as 'marrying-up'. It entailed cramming your cab full of squaddies and charging a fixed price per individual who were all heading for the same station. In retrospect it made sense, the ranks were cleared much quicker, the squaddies got a cheap cab ride and the cabbies earned an extra few bob in the process. But the 'Old Bill' didn't see it that way one little bit. In their blinkered way of thinking this practice was a blatant contravention of the Hackney Carriage Laws and was interpreted as a serious criminal offence. So they lay in wait for

Ranking up again
at a London station.
(LVTA Archive)

the nefarious cabbies as they made their way – well overloaded of course – to the various stations. Many wartime cabbies tell me that the 'Old Bill's' favourite hiding place for those bound for Waterloo station was just around the corner from Bush House in the Aldwych. Then they would leap out and descend on the poor old cabbie as if he was a bank robber, and a heavy fine – plus an endorsement on his licence – would follow. But, being a licensed cabbie, that wasn't the end of the matter, he would receive a snotty letter from our ruling body, the Public Carriage Office, demanding his appearance to explain his digression. The simple fact was that the very conservative PCO ruled all things 'cabbie' – and they still do – and, if they weren't satisfied with your explanation, they'd take away your cab licence for a certain period – so bang went your living!

But because of National Service, the practice of 'marrying-up' continued right through to the early 1960s. The cabbies described it as, 'Working the earlies', when most of the National Service guys arrived in their thousands at London's main railway terminals very early on Monday mornings. They had enjoyed a weekend pass at home and were heading back to their camps scattered all over southern England. The experienced cabbies knew the arrival times of all the 'Earlies' – racing from one station to another after delivering their overloaded cargo. And when I say 'overloaded' I really mean overloaded, often carrying as many as eight squaddies in a taxi only licensed for four persons! The word would soon get around as to where the Old Bill was hiding – especially if one of their firm had already been nicked – so they would select an alternative route. The squaddies weren't bothered what route they went – not that they knew, because the price was the same!

Moving up to the present day on the same subject, this practice of 'marrying-up' has been made perfectly legal at two of London's main line stations. The Licensed Taxi Drivers' Association (LTDA), the trade's biggest association, in tandem with the station authorities, have devised a scheme to help clear the ranks during the early-morning rush – especially at Paddington station with the massive influx of long-haul passengers arriving on the Heathrow Express. LTDA marshalls go down the ranks at Paddington and Euston stations asking the punters if they'd like to share a taxi. If they agree they are asked their destination and given a card stating the appropriate shared price. There is a dedicated 'shared–rank' alongside the main rank and groups of punters heading for the City, the West End or elsewhere, are put into the first cabs on the shared-rank by the marshalls. So the punters not only get a cheap ride, they also don't have to wait in a long queue, while the cabbies on the 'shared-rank' earn extra dough.

With the war finally over and all our boys back home again, it was back to normality for the London cabbies. Well not quite, because the returning military guys who held taxi licences couldn't get a cab to go to work. Many cabs had been destroyed serving in the AFS, while many more were wiped out in the air raids, and try as they might, Mann & Overton, the principal cab dealer, just didn't have the spares to get many of the old cabs back on the road. The result of this was that by 1945 there were fewer than 3,000 taxis fit for use in London.

CHAPTER EIGHT

The Post-War London Taxis

The very first post-war taxi to appear in London in 1946 was the Nuffield Organisation's Wolseley 'Oxford'. They had been running their prototype right throughout the war and managed to get it on to the market some eighteen months before Austin's new model the FX3, which was launched in 1948.

Many people considered the FX3 a superior vehicle, with an all-steel body by Carbodies of Coventry. Carbodies continued to provide coachwork for London taxicabs for many years and, when it finally became London Taxis International (LTI), the new company then made the complete cab at their massive works in Coventry. As with many other companies seeking to cut costs, LTI – now owned by Manganese Bronze – have outsourced much of their taxi-manufacturing business to China and, now, our famous London and world 'icon' is manufactured mainly in Shanghai. How the world has changed since I entered the taxi trade!

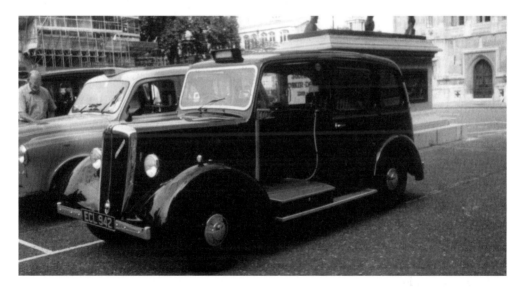

One of the Beardmores. *(LVTA Archive)*

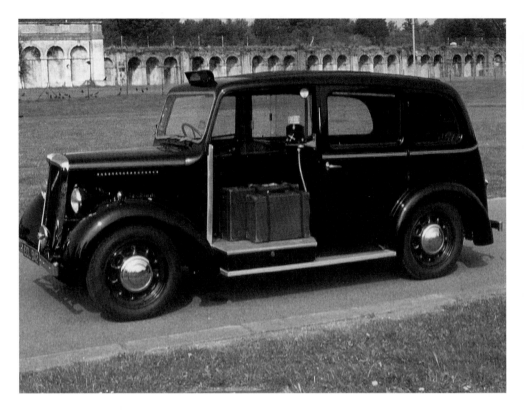

The shapely Beardmore. *(LVTA Archive)*

The sales of the FX3 soon overtook the sales of the Oxfords and by 1954 there were almost 5,000 FX3s on the road compared to under 2,000 Oxfords. But another major factor arose that would prove the death knell for the Oxfords. After the Austin-Nuffield merger in 1952, there was not room enough for two taxis in the now-named British Motor Corporation and, as the FX3 of Austin was the more modern design, the popular old Oxford was dropped like a hot potato!

The FX3 was the very first taxi to have a fully enclosed driver's compartment, with a sliding window on the left. It also had an enclosed luggage compartment at the rear, plus additional luggage space next to the driver. The FX3 was the very first taxi I drove after completing the Knowledge in the winter of 1962 and it was bloody freezing in the icy, cold weather. There was just one small rubber heating pipe that went into the driver's section, so all the guys used to reverse the heating pipe in the passenger compartment back into the driver's section! The FX3s were very nippy, but they had a down-side – the old-fashioned rod-brakes had a nasty habit of pulling sharply either to the left or the right when you braked hard. I recall picking my cab up to start night work and the day driver had stuck a note on the windscreen which said succinctly, 'She pulls to the right'! During its ten-year life span the FX3 boasted two important improvements: the diesel engine

and automatic transmission. The cab trade had seen spiralling fuel costs of some 80 per cent compared with pre-war days and the innovation of the small diesel engine was like manna from heaven – especially in September 1954 when Austin brought out their own 2.2 litre diesel engine. Even though the price of a diesel-engine cab was around £100 more than the petrol powered model, most cabbies thought the extra was worthwhile and a year later Mann & Overton were selling nine diesels to every one petrol cab sold. As for the automatic transmission on the FX3, that was never offered by the makers. But York Way Motors – a great cab firm owned by Wally Levy and now sadly defunct – fitted eighteen of their cabs with Borg-Warner automatic gear boxes. These proved very popular with the 'journeymen', those cabbies who worked 'on the clock' for them and this experience led to them being standardised on the very first of the FX4s in 1958. Apart from its huge popularity in London, the FX3 was the very first London taxi to be exported worldwide, with foreign sales of 700. The majority of these went to European countries but they didn't prove to be popular in the United States because they were underpowered and couldn't compete with the 100 or more brake horsepower of the big American taxis.

The famous Beardmore entered the market again in 1954 with their Paramount Mark VII, powered by a 1508cc Ford Consul engine and gearbox. It was the first London taxi

This one needs a lot of work. (*LVTA Archive*)

One old, one not so old. *(LVTA Archive)*

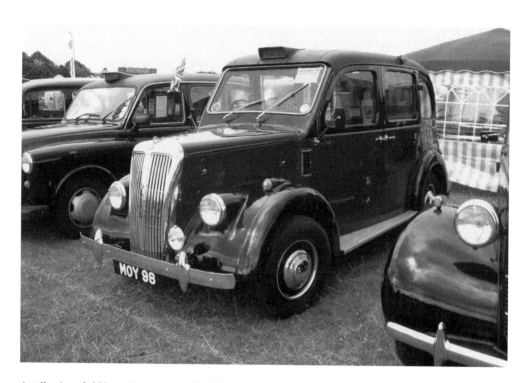

A collection of old beauties on show. *(Taxi Archive)*

to have a steering column gear change. They introduced a Perkins diesel engine in 1958 that proved more popular than the Ford Consul and in 1965 they put on a fourth door, enclosing the luggage area. This was a great cab with an aluminium-panelled body and coach-built to perfection, in fact I put my name down to order one of these beauties. I thought that it was such a great cab that it could easily top the sales of the FX3. But sadly, by the time my name had reached the top of the list, Beardmore had suddenly departed from the cab market after fifty successful years and was never heard of again.

In September 1958 the FX3 was replaced by the FX4, an all-new design developed by Austin and Carbodies. After my disappointment with the Beardmore collapse, I decided to splash out and buy one in 1963. I believe the price was around £1,200 at that time – all paid for on the never-never of course and I thought that was a small fortune. But what about the cabbies buying a new TX4 today, their never-never bill would amount to the best part of £40,000!

The FX4 ruled the London taxi trade virtually unchallenged for thirty-eight years and, along with the Mini, became one of the longest-lived of British car designs. Some 75,000 FX4s were produced from 1959 right up until 1997, when the TX1 came on the scene. In between times various new edicts were being directed at the trade. For many years our trade associations had been pushing the PCO to allow rear view mirrors in taxis as a safety backup. Then in 1968, our wishes were finally granted and it became a legal

The popular FX3. *(LVTA Archive)*

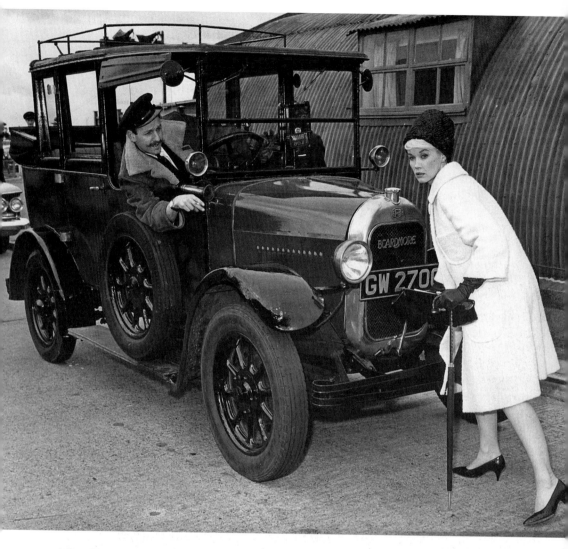

A Beardmore being used on a film set. *(LVTA Archive)*

requirement to have rear view mirrors in all London taxis. But being the PCO it wasn't all plain sailing, they decreed that all rear view mirrors should be secured firmly to the bulkhead and be non-adjustable. It was alleged that the authorities didn't want randy cabbies ogling the legs of their lady passengers. The totally useless rear view mirrors became a standing joke among the guys and they used to say the mirrors were great for spotting low-flying aircraft and pigeons! Then in 1990 the authorities permitted exterior advertising on all London taxis, which could – and should – have been a massive earner for the drivers – especially the fleet owners with plenty of cabs. I can recall one of my passengers who was an advertising executive, saying to me that a London taxi was

considered in his business as a 'prime moving advert'; with its advertising, it travels past all the premium locations in the capital like Buckingham Palace, Tower Bridge, etc. When I told him the annual rate the guys were getting for a full livery from the companies that had sprung up almost overnight, he was shocked. He reckoned the cabbies and fleet owners should be receiving five or six times as much as they had signed up for on the dotted line. But it didn't surprise me one little bit, because over the years the trade has always sat on its hands while the shrewd money men have walked away with all the goodies!

But one ex-cabbie did get on the gravy-train of external taxi advertising – eventually making him a millionaire. Asher Moses, an old mate of mine from way back, had built up quite a sizeable fleet of cabs with his partner and, with the advent of taxi advertising

The Winchester. *(LVTA Archive)*

The Winchester taxi. *(Taxi Archive)*

My cab livery, compliments of Asher Moses. *(Author's Collection)*

he came up with this brilliant but simple idea of getting in on the action. He had this notion of covering forty-nine of his cabs with advertising for every single state in the USA. One would advertise, say, Florida, another Louisiana and so on. He took his idea to the American Embassy and they directed him to the tourist department. They were immediately sold on the idea and Asher walked away with a contract worth several hundreds of thousands of pounds – plus the drivers of these cabs would benefit with a free week's holiday in the relevant state, just talking about the wonders of our great city! By sheer hard work and dedication Asher and his Taxi Media Organisation, which he owns one hundred per cent, have basically cornered the market for taxi advertising with a turnover of many millions a year. But, like most London cabbies who managed to make the big time, Asher is still a very friendly and humble family man who continues to support the trade that gave him his start. For instance when I required a livery on my cab

The early Metrocab. *(Taxi Archive)*

to advertise my latest book, it was deep into the recession and my publishers couldn't afford the cost. Much to my delight, a quick phone call to Asher and he did it for free because he respected all the work I had done for the trade over the years.

Talking of successes, in 1978 I managed to win the very prestigious 'Taxi Driver of the Year' competition. This was followed by various appearances on TV and radio promoting our trade. My very first invitation during my 'reign' was to drive my cab behind the Lord Mayor's coach in the annual parade (see pictures below and opposite). After lots of effort in persuading the organisers, I managed to get permission to have all my family in the back on the parade, the first and only time it has happened.

But I digress, for sure there were some makers that attempted to break the stranglehold of the FX4 like the Lucas electric taxi, the Winchester and in the 1990s, the Metrocab. But they all went to the wall because they couldn't attain enough of the market share. In the case of the Metrocab I found that rather strange, because it was an excellent taxi with a fibreglass body that beat the rust suffered by the FX4. In fact I liked them so much I bought one in 1999, despite some of the guys saying they looked like 'a bleedin' hearse',

Posing in the Lord Mayor's Show, 1978. (*Author's Collection*)

In the Lord Mayor's Show as Taxi Driver of the Year, 1978. *(Author's Collection)*

and some eleven years later it is still going strong. Metrocab then introduced their TTT model, again another excellent cab which proved extremely popular with the drivers. But just like Beardmore before them, they suddenly shut up shop and disappeared.

Over the many years that the FX4 ruled the streets of London, not too many changes occurred to the original design. They introduced the FX4R, with a 2,286cc diesel engine and a five-speed, all-synchromesh gearbox, both manufactured by Land Rover Limited. This became a virtual disaster because the engine was sluggish and underpowered. I recall driving one of these beasts and I often used to jokingly say in my articles, 'If you're going up Highgate Hill in an FX4R, don't be surprised if you are overtaken by a milk float, or by two coppers on a tandem!' During this period the traditional 'For Hire' sign was changed to 'Taxi' – an international word. This helped to assist our foreign tourists and visitors.

Then along came the Fairway and the Fairway Driver, all excellent improvements that stretched the longevity of the FX4 even further. The FX4 was recognised all over the world as a London icon, so subsequently they began to be exported to countries all over the world like Dubai, Saudi Arabia, Lebanon, Kuwait and Japan. In 1984 Carbodies made their first sale in the United States with an order for 500 cabs to Detroit, the contract stating that engines and transmissions were to be fitted in America.

The story of the London taxi changed again when LTI (London Taxis International – the name of the new company forged from Carbodies and the buy-out of Austin) introduced

Jamie Borwick (former MD of LTI) with Steven Norris (former Minister of London Transport) pose for the launch of the 500th TXI. *(Author's Collection)*

the TX1 in 1997. This was known affectionately in the trade as 'The Noddy Car', simply because it really did look like one! Yet again the TX1 proved to be a winner among the drivers and it wasn't too long before the TX2 hit the streets leading up to the latest London taxi, the TX4. Why not a natural continuity by naming it a TX3, you may ask? Well, the same year as the launch, the European Union was itself launching an important 'Euro-Four Emissions Law' and I guess that LTI wanted to use that as their marketing ploy to flog their new taxi.

Even though the TX4 is a great taxi and very popular among the 'mushers', it's extremely expensive at around £34,000 and, I'm reliably informed, very heavy on the 'juice'. The obvious way forward in the future – especially with a major crackdown on London's

emissions – will be the hybrid or the electric taxi. Mercedes-Benz, with their Vito model, have already successfully bypassed the stringent 25ft turning circle demanded by the Conditions of Fitness and I can foresee a possible future of not one single, purpose-built London 'icon' on the streets anymore. A cheaper, more modern alternative vehicle is what the younger drivers want and maybe that's progress, but I'm not too sure!

We've come a long way since Captain Bailey, a retired mariner, started the world's very first taxi rank in 1635. In those far-off days all the Hackney coaches used to park up outside the inns situated in the side streets and were hidden from view. But Captain Bailey dressed the drivers of his four coaches in smart livery, smartened up the coaches and instructed them what fares to charge, then placed them one behind the other close to the Maypole in The Strand for all to see. This rank proved extremely popular, so much so that other Hackney

The stylish TX4. *(Taxi Archive)*

coachmen flocked there seeking work. It became so popular that the modern-day cabbies still adopt the same practice of slowly driving along the streets – just waiting for a space on a fully-loaded rank – we cabbies call it 'mooching'.

Right throughout the centuries the London cabbies have fought long and hard to protect their trade, starting with the thirteen-year battle with the Watermen, then the Sedan Chairs, followed by the harsh and stringent rules laid down by the Hackney Coach Office, (the original name of our ruling body), that almost bankrupted the trade – especially when they decreed that all taxis must be four-seaters.

The trade suffered a dearth of cabs being produced in the First and Second World Wars because all the factories were producing military hardware. Then came two major strikes in the First World War against the fleet owners and no fare increases whatsoever from the

Cabs waiting outside the old PCO for their annual overhaul examinations. *(LVTA Archive)*

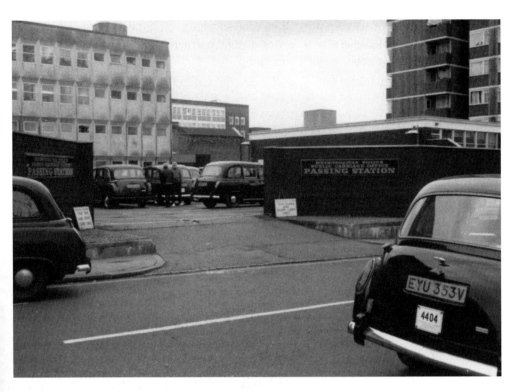

The now-defunct Public Carriage Office. *(LVTA Archive)*

then Home Secretary, a certain Winston Churchill, from 1907 to after the Armistice in 1918. But still the cabbies carried on providing a service to the public in their old, clapped-out vehicles.

The future of our trade is looking a bit tenuous to say the least. We have always existed because of our superb geographic knowledge of London and our world-famous icon the London taxi. But the new guys and gals coming into the trade believe our 'icon' is old-fashioned and too expensive and they are demanding a cheaper alternative vehicle to challenge LTI's monopoly. Consequently, the trade organisations are responding to their members and pushing for alternative vehicles as taxis. But, as I said earlier, the longevity of our famous, purpose-built taxi has been mainly down to the 25ft turning circle that's a requirement of the Conditions of Fitness.

Then enter the shrewd, Teutonic engineers working for Mercedes-Benz. They simply fitted a rear-wheel steering device onto one of their Vito models that could be used at the press of a button and, hey presto, it completed the 25ft turning circle and about 800 of them are now licensed taxis working the London streets! Many of the guys sneer at the Mercedes Vitos and call them 'Bread Vans', but my biggest concern is that if the Vito can beat the 25ft turning circle, what will our trade be like if a dozen or more car makers decide to adapt the rear-wheel steering device?

The Mercedes Vito taxi, called 'the Bread Van' by many cabbies. *(Taxi Archives)*

Will we finish up like the trade in the decade before the First World War when some thirty-eight different makes, all vying for a piece of the lucrative taxi market, were licensed as taxis? Many of these manufacturers were simply entrepreneurs and didn't understand the taxi market and by the outbreak of the First World War, they had all gone broke and just one taxi, the old Unic, was on the road.

The London taxi trade has always been closely associated with the Public Carriage Office – they took care of everything 'taxi'. However, over the last few years, things have changed dramatically. First to go to a new address was the Lost Property department, followed by the outsourcing of all taxi overhauls to SGS. Finally, the PCO closed after more than 100 years' operation and we are now lumped together with our opposition, the newly licensed Private Hire – indeed, the department is now called 'Taxi and Private Hire'. How long before the two are totally merged I ask myself. . . .

Well, if we cabbies can survive two world wars, getting bombed, risking life and limb, and mucking in to help on the home front, I am sure we can ride out any storm.

Other titles published by The History Press

Blitz Boy
Alf Townsend
978-07509-5068-8
Blitz Boy is a fascinating recollection of life in the Blitz and of evacuation to Cornwall. Charismatic author Alf Townsend tells the harrowing and touching tale of what it was like for a young inner-city child to suffer the trials of war at first hand.

The London Cabbie
Alf Townsend
978-07509-4496-0
Forty years ago Alf Townsend passed 'the Knowledge' – after 14,000 miles on a moped round central London. Since then he has covered millions of miles in his taxi. This book includes a selection of his extraordinary and hilarious tales of everyday life as a cabbie, in which we meet Mr Whippy and Violent Pete, Bread Roll Mick and the Motorway Mouse, Claude the Bastard and the mysterious Mr X. This is entertaining reading for all Londoners, and anyone else who has had the pleasure of travelling in the back of a black cab.

The Black Cab Story
Alf Townsend

978-07509-4853-1
This is the complete story of the black cab, from its origins at the time of Oliver Cromwell to the brand new taxis which now grace the capital's streets. This light-hearted romp through the world of 'the Knowledge', the vehicles, the streets of London and the cabbies themselves, is a must-have for anyone who loves this world-famous London icon.

Visit our website and discover thousands of other History Press books.

www.thehistorypress.co.uk